ID0792078

|DIGNITY|

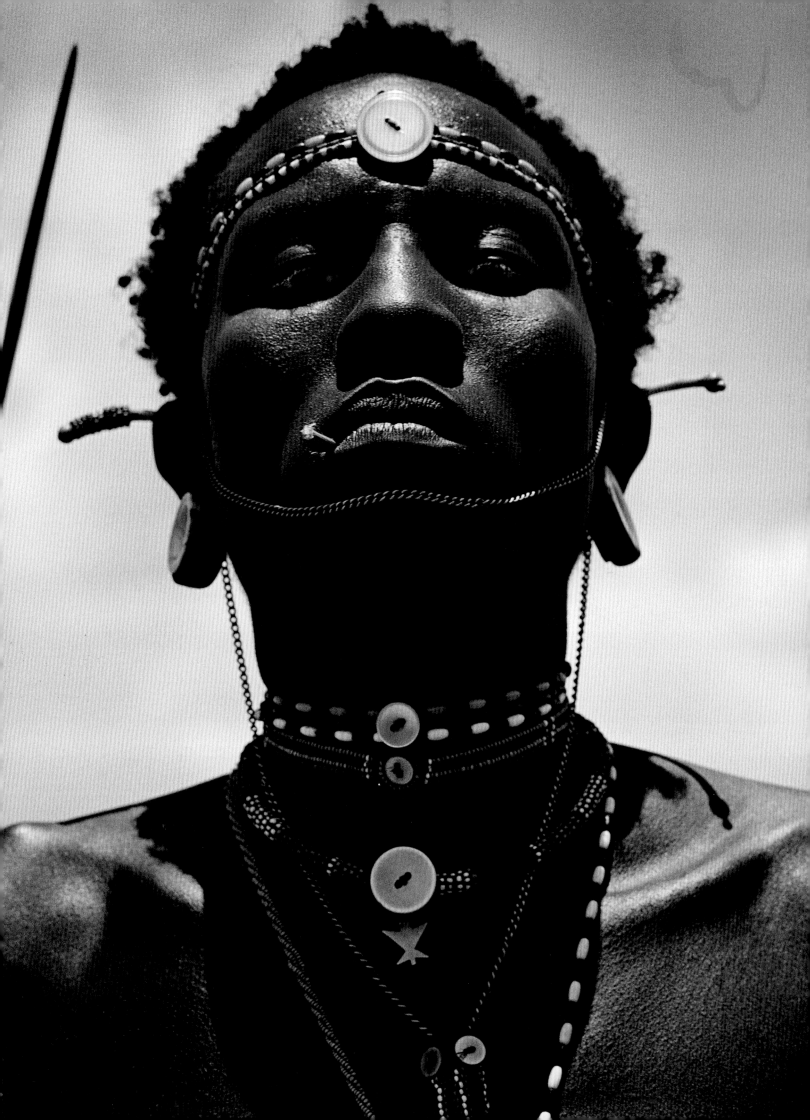

uckstein, Dana.
gnity : in honor of
e rights of indigenous
10.
3052224
03/14/11

|DIGNITY|

In Honor of the Rights of Indigenous Peoples
Foreword by Archbishop Desmond Tutu, Introduction by Faithkeeper Oren R. Lyons

PHOTOGRAPHS BY DANA GLUCKSTEIN

powerHouse Books
Brooklyn, NY

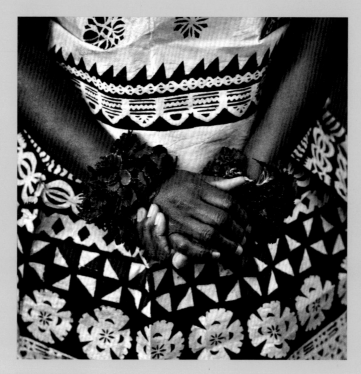

Dancer, Fiji, 2008

| DIGNITY |

TABLE OF CONTENTS

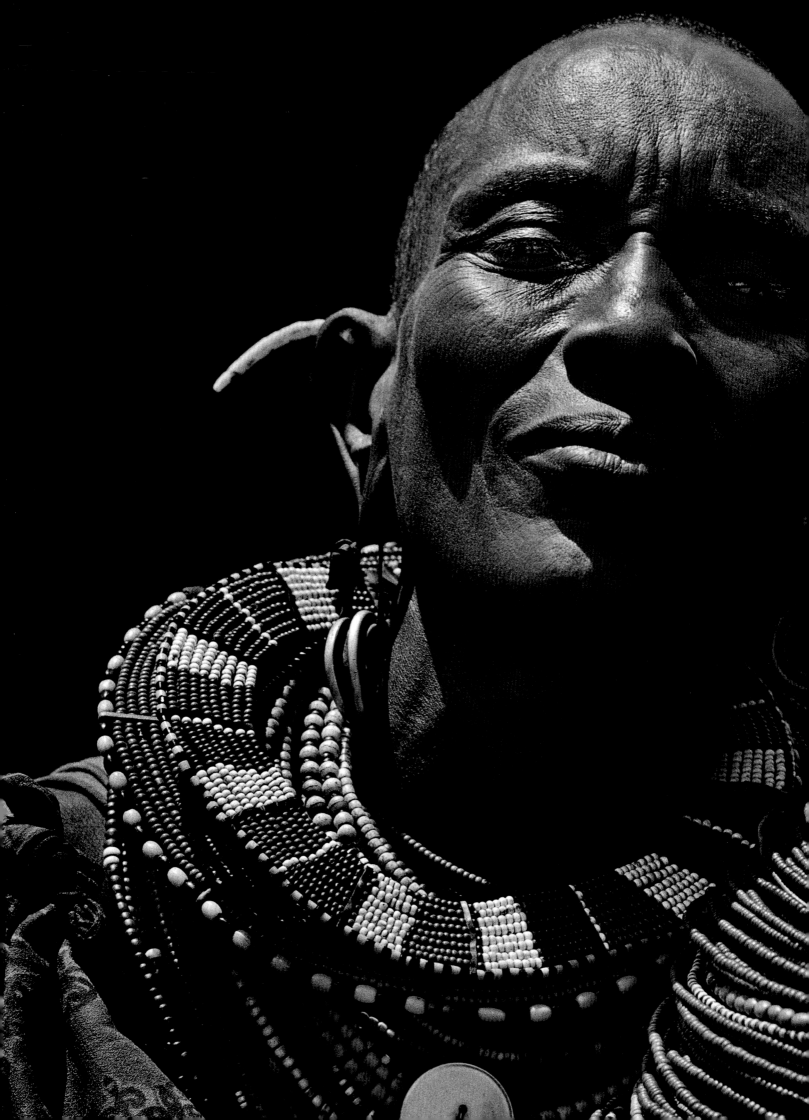

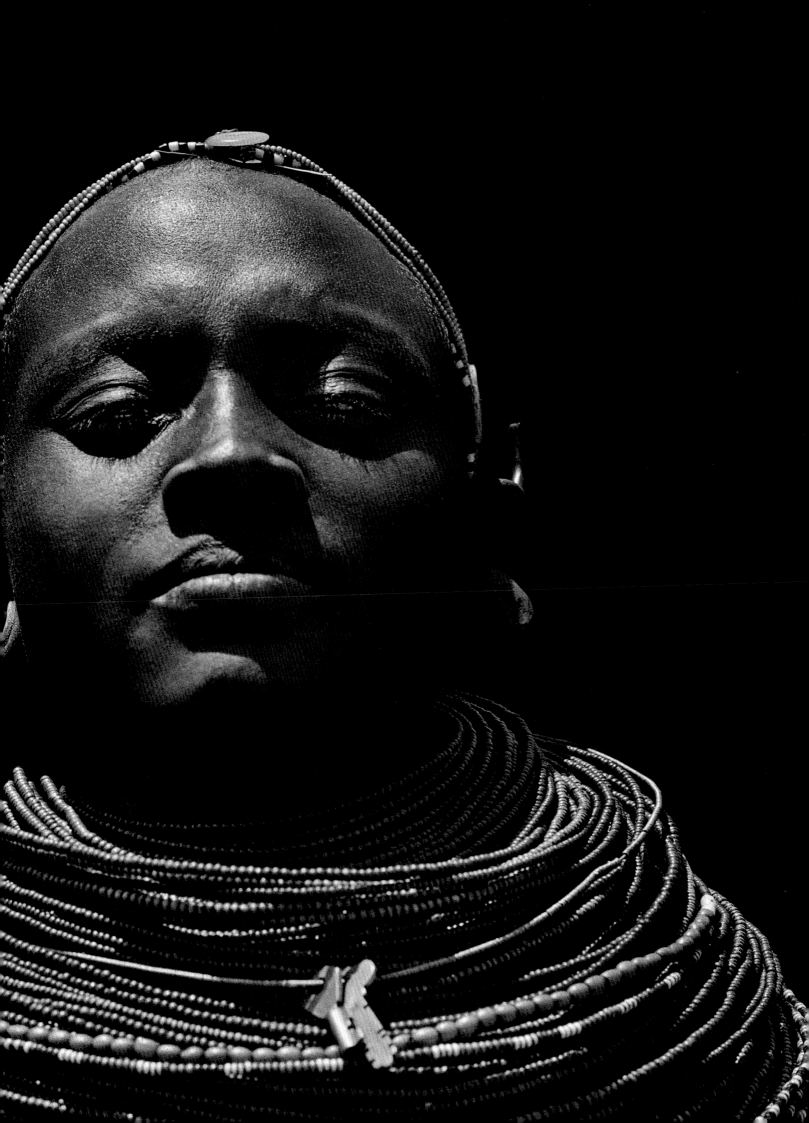

| ARCHBISHOP DESMOND TUTU |

FOREWORD

INDIGENOUS PEOPLES THROUGHOUT THE WORLD have something profound and important to teach those of us who live in the so-called modern world. I have long believed this to be true, even before I discovered to my delight that I was related to the San People of southern Africa. I suspect that if each of us looks far enough back into our genome we will discover that we are all indeed related.

Indigenous Peoples remind us of this fact. They teach us that the first law of our being is that we are set in a delicate network of interdependence with our fellow human beings and with the rest of creation. In Africa recognition of our interdependence is called *ubuntu*. It is the essence of being human. It speaks of the fact that my humanity is caught up and is inextricably bound up in yours. I am human because I belong to the whole, to the community, to the tribe, to the nation, to the earth. *Ubuntu* is about wholeness, about compassion for life.

Ubuntu has to do with the very essence of what it means to be human, to know that you are bound up with others in the bundle of life. In our fragile and crowded world we can survive only together. We can be truly free, ultimately, only together. We can be human only together. To care about the rights of Indigenous Peoples is to care about the relatives of one's own human family.

The Indigenous Peoples of the world have a gift to give that the world needs desperately, this reminder that we are made for harmony, for interdependence. If we are ever truly to prosper, it will be only together.

And this also includes what used to be called "inanimate nature," but what the elders have always known were relatives in the family of earth. When Africans said, "Oh, don't treat that tree like that, it feels pain," others used to say, "Ah, they're pre-scientific, they're primitive." It is wonderful now how we are beginning to discover that it is true—that tree does hurt and if you hurt the tree, in an extraordinary way you hurt yourself. Every place you stand is holy ground; every shrub has the ability to be the burning bush, if we have eyes to see.

We owe a very great debt of gratitude to those who remember the old ways to live and honor the earth. And yet, we have ignored them, oppressed them, and even stripped them of the land that is their life. The United Nations Declaration on the Rights of Indigenous Peoples is an important step toward protecting these vulnerable members of our human family, of giving them the dignity and the respect that they so richly deserve.

We must be grateful to those who remind us of our common bond. The work of Dana Gluckstein embodies *ubuntu*. It helps us to truly see, not just appearances, but essences, to see as God sees us, not just the physical form, but also the luminous soul that shines through us. Pick up this glorious book and look into the eyes of your relatives, those distant cousins you have not seen in so many years, for whom your heart ached without knowing. Greet each other again, with the love and healing that comes with reunion, and know that in protecting their rights and their way of life, you protect the wellbeing of us all and the future we share, for we are all, every one of us, precious members of the family of earth.

God bless you,
DESMOND TUTU

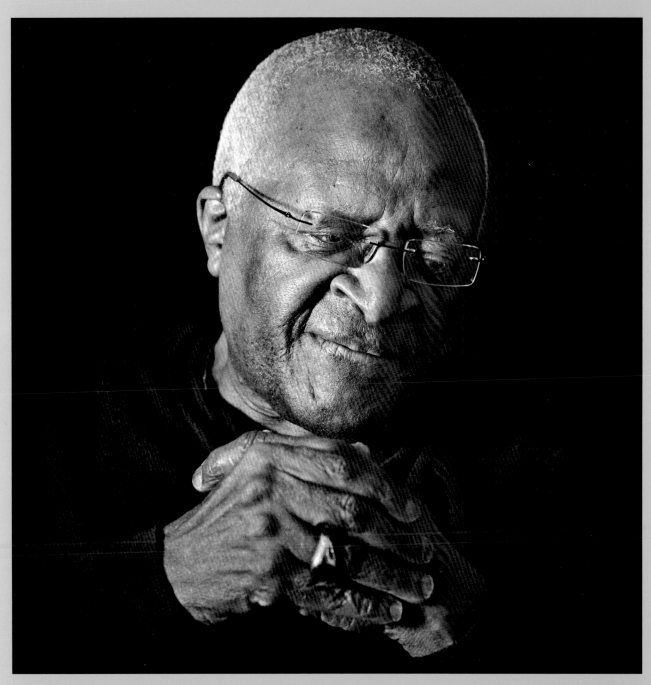

Archbishop Desmond Tutu, South Africa, 2009

| OREN R. LYONS, FAITHKEEPER |

INTRODUCTION

A Perspective

THE STORY OF THE INDIGENOUS PEOPLES has always been told by our oppressors, and the myths of 15th-century medieval Europe continue to resonate into the 21st century. In August 1977, 146 delegates from the indigenous nations and communities of North, Central, and South America, as well as Scandinavia, made a historic journey to the United Nations in Geneva to dispel these myths. We carried the hopes of our indigenous nations, seeking justice for centuries of unspeakable crimes against our peoples. The United Nations was, to us, a beacon where, at last, an international tribunal would address and begin restoration of our embattled peoples who were struggling for survival in what was left of our homelands.

In the context of today's politics, we might be thought naïve. But we did then, and still do, believe in a spirit of equity, honor, and justice embedded within humanity. We believe that humanity can bring about responsible leadership and selfless attitudes that will ensure a good life for future generations. And so, when we traveled to the United Nations in 1977, we believed it was finally the time for a new global policy, a Doctrine of Recovery.

Although we did not know it then, that doctrine ideally would replace the Doctrine of Discovery, a doctrine that had arisen from 15th-century medieval Europe and that continued to resonate for five centuries. The quest for a Doctrine of Recovery, as embodied in the United Nations Declaration on the Rights of Indigenous Peoples, cannot be grasped without an understanding of the dark history of the Doctrine of Discovery.

The discovery of the Western Hemisphere presented an opportunity and a quandary for the countries of Europe. At that time Europe was suffering through a succession of plagues that swept through cities and provinces. Famines, often induced by royalty and others of privilege, were common. Standing armies, royal guards, and sheriffs protected these families and enforced a complex system of exchange that traded survival and food for human labor. The most powerful political entity was the Roman Catholic Church. The church conferred sanction and patronage on the armies of Christian countries, who in turn defended the pope's power. Christian doctrine was coercive, enforced by the

Inquisition of Catholic law. A simple accusation of heresy could lead to torture and death.

At the time of discovery, however, the Catholic Church's hegemony was threatened. During the reign of Henry VII, the Church of England challenged the power of the Vatican. The discovery of the Americas itself in 1492 provided the feuding pope and king with a joint target—the Indigenous Peoples of the Western Hemisphere. With one sweeping declaration, breathtaking in its scope of arrogance, power, and racism, Pope Alexander VI in 1493 granted to Spain all lands not under Christian rule in the newly discovered regions. King Henry VII quickly followed with a royal charter that proclaimed that Christian monarchs had the right to dominion and ownership over the lands of Indigenous Peoples because they were not Christians. The new lands were treated as if they were empty lands, Terra Nullius, and devoid of human inhabitants, Terra Nullus. Other European nations challenged the idea that one Christian sovereign had title over the entirety of the Americas, but they all agreed with Terra Nullius' and Terra Nullus' dictates. What emerged was the religious-political construct known as the Doctrine of Discovery, that evolved into the Law of Nations and ultimately the system of international law still in effect today. The Catholic Church's 15th-century feudal laws therefore remain part of modern law despite the principle of separation of church and state.

When we traveled to Geneva in 1977 to demand our rights, none of us knew this history. We were just discovering the oppressive religious and political origins of the doctrine. In Geneva, my own people, the Haudenosaunee, more commonly known as the Six Nations Iroquois Confederacy, introduced three position papers on politics, law, and economics entitled, *A Basic Call to Consciousness: The Haudenosaunee Address to the Western World* [1]—a concise history of how the feudal system of Europe developed into the governing systems of the industrial states today. In the great halls of the United Nations we heard inspiring speeches and good words. We found allies in this quest for justice and survival, many of whom were poor people who recognized our common cause. We also found brilliant exceptions among people in positions of power who brought

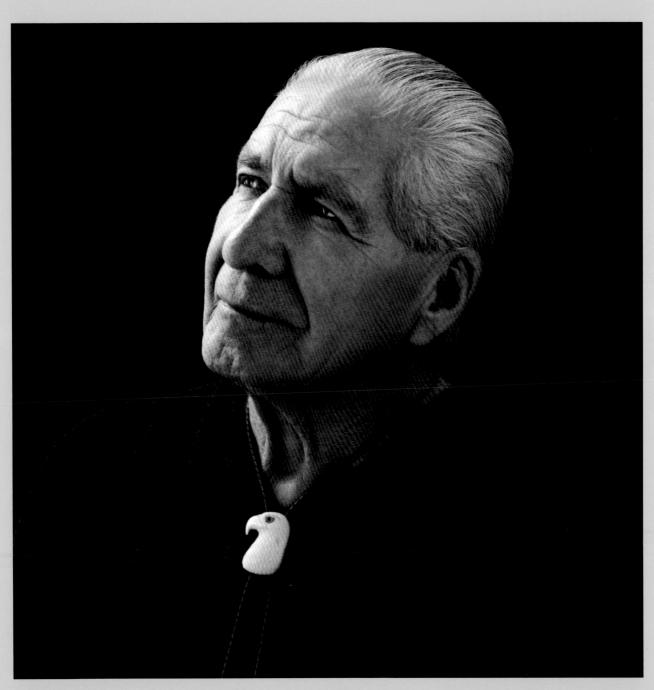

Oren R. Lyons, Faithkeeper, Turtle Clan, Onondaga Nation, United States, 2009

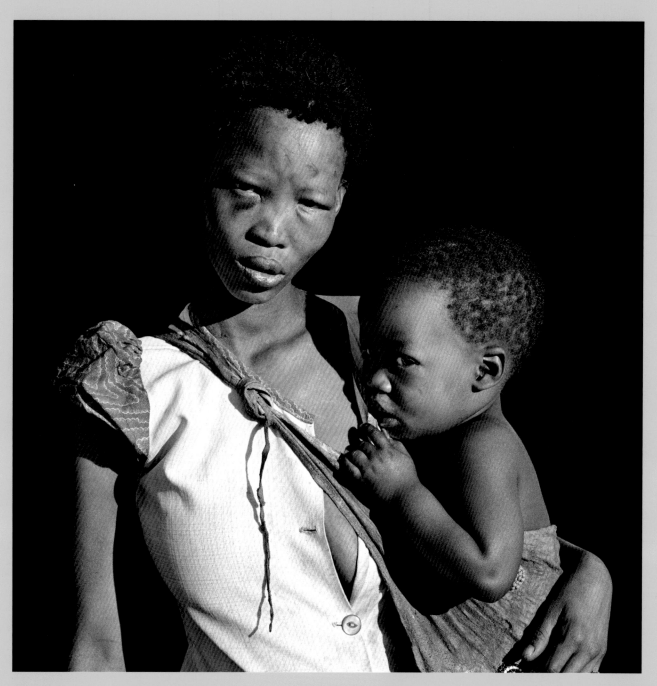

San Bushmen Mother and Child, Botswana, 2009

intense and uncompromising spirit and leadership to the task. Ultimately, however, national self-interest prevailed. We realized that the political forces that had stymied us in our homelands were also hampering us in the international arena. This trip to Geneva, we understood, was one step in a long journey of survival for Indigenous Peoples.

Our stamina and understanding of this epic struggle enabled us to keep up the fight for three decades. The centuries of oppression crystallized the values that sustained us and allowed us to stay focused in a world where the moral compass was spinning. On September 13, 2007, the General Assembly of the United Nations in New York adopted the Declaration on the Rights of Indigenous Peoples. We were finally recognized as peoples with an "s". In the vernacular of the U.N., *people* is generic; *peoples* is specific. The day before, on September 12, 2007, we were still referred to as populations or as issues, and, occasionally, as people—but not as a people who deserved international recognition. These designations, consistent with the tenets of the Doctrine of Discovery, denied us human rights.

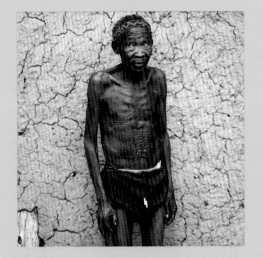

San Bushman Healer, Botswana, 2009

The Declaration on the Rights of Indigenous Peoples recognizes the 370 million indigenous individuals of the world—our names, our communities, and our nations. Our recognition was momentous not only for the Indigenous Peoples of the world, but also for the states represented by the General Assembly of the United Nations. The Assembly's decisive action struck down, or at the very least, delivered a hard blow to the racist doctrine that had imprisoned all humanity—the gatekeepers as well as their indigenous victims—since 1492. The United Nations Declaration on the Rights of Indigenous Peoples was the longest vetted document in the history of the United Nations.

The adoption of United Nations Declaration on the Rights of Indigenous Peoples was not a complete victory: 144 states voted for the declaration, 11 states abstained, 34 states did not participate, and four states—Australia, Canada, New Zealand and the United States—voted against it. The disturbing fact that four states voted against the human rights of Indigenous Peoples and 45 states were more or less neutral indicates how much work remains to be done to bring all the states of the world to acknowledge the rights of Indigenous Peoples. In 2009,

Australia adopted the declaration with a public apology to the Aborigines. In April 2010, New Zealand adopted the declaration after much public protest and the United States announced a "formal review" of its position. It is anticipated that President Obama will soon adopt the declaration. The declaration itself requires an additional step to become a United Nations Convention and thus officially be part of international law.

We move forward with the help and support of friends and allies. Dana Gluckstein is one of those important friends. I met Dana in 1989 at the international Gathering of Elders at my home in Onondaga, New York. She has dedicated herself to the advancement of Indigenous Peoples through her art and the publication of this historic book.. Her work is imbued with sensitivity and love for those she has photographed. Dana has captured the quiet dignity and strength of people who know who they are. I was humbled by her request to write this introduction. I do so with respect, love, and appreciation for her compassion and her presence on this earth.

A thousand years ago or more, the Great Peace Maker came among our people. He introduced the principles of peace, health, equity, justice, and the power of the good minds, which is to say, to be united in thought, body, and spirit. He brought peace to our warring nations and he raised new leaders, clan mothers and chiefs, instructing us on our conduct and our responsibilities. Among those many instructions, one continues to resonate around the world today. He said to us, "When you sit in council for the welfare of the people, think not of yourself, nor of your family, or even your generation. Make your decisions for the seventh generation coming so that they may enjoy what you have here today. If you do this, there will be peace." That is a profound instruction on responsibility that should be the basis for the world's decision makers today.

Dah nay to (Now I am finished).
**OREN R. LYONS, FAITHKEEPER, TURTLE CLAN,
ONONDAGA NATION COUNCIL OF CHIEFS
HAUDENOSAUNEE**

1. Akwesasne Notes, *Basic Call to Consciousness* (Summertown, TN: Book Publishing Company, 2005).

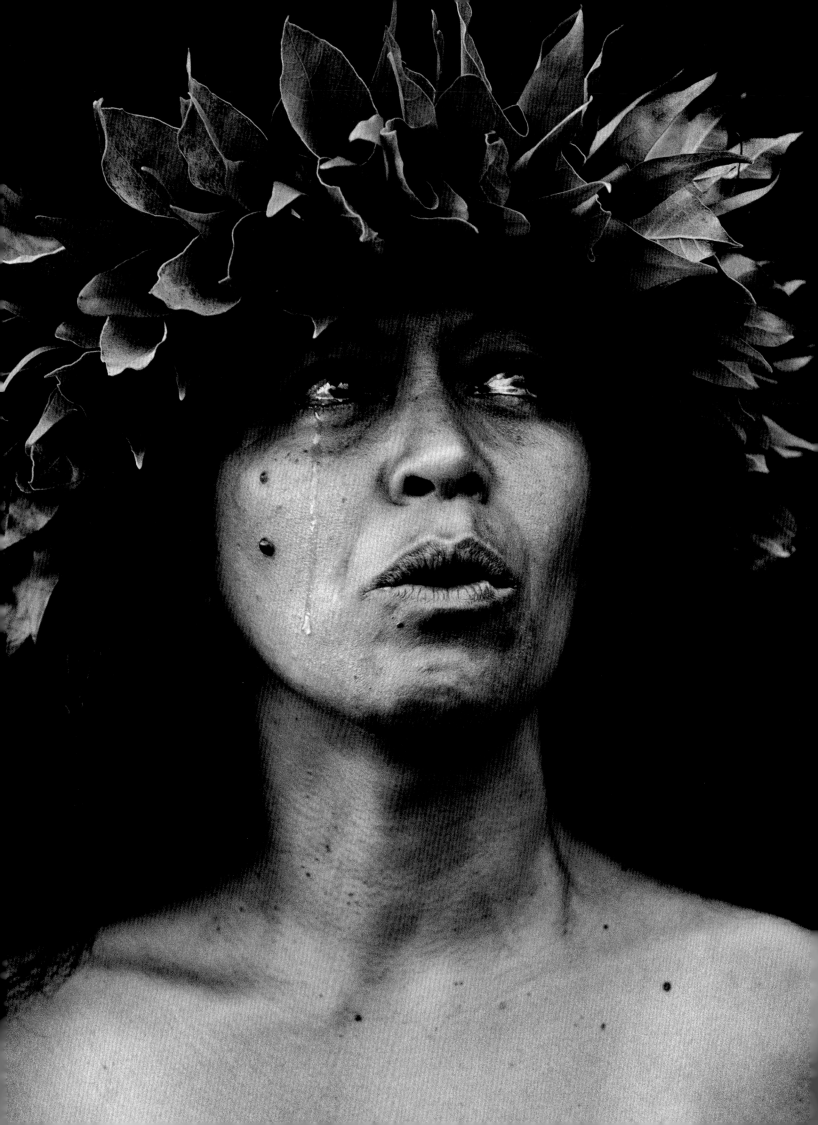

|DIGNITY|

PAGE 14: *Chanter, Hawaii, 1996*
OPPOSITE PAGE: *Tribal Man in Transition, Kenya, 1985*

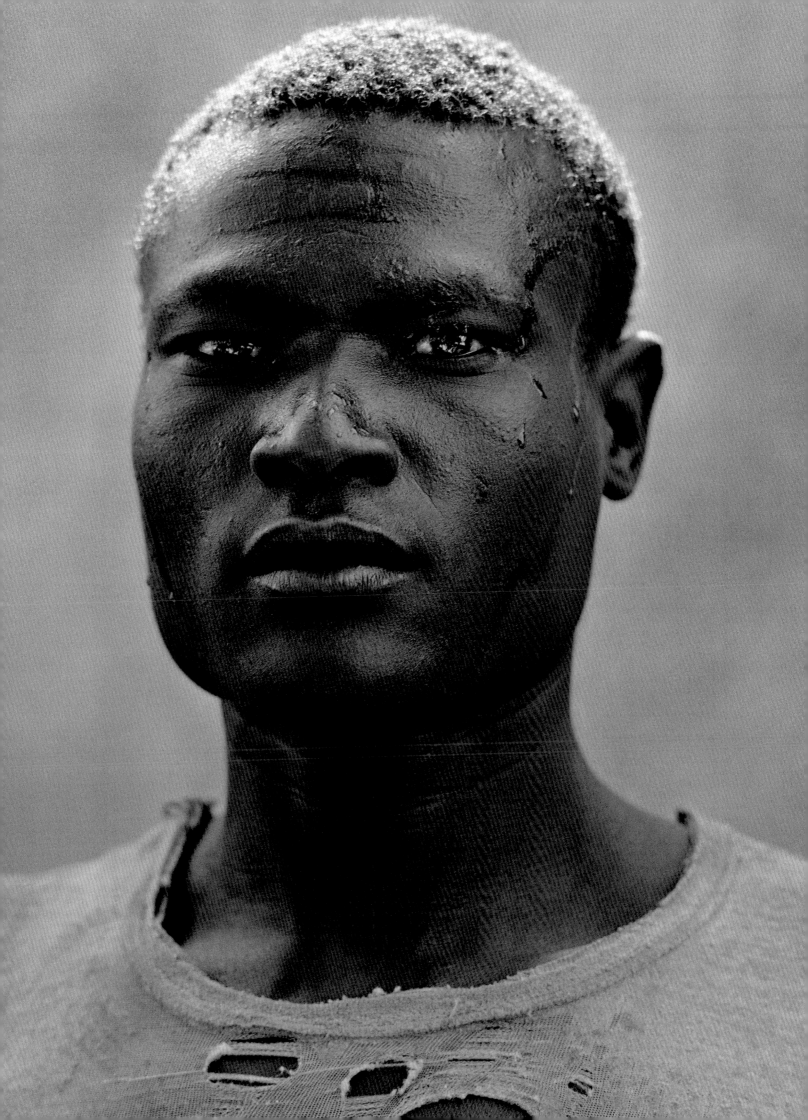

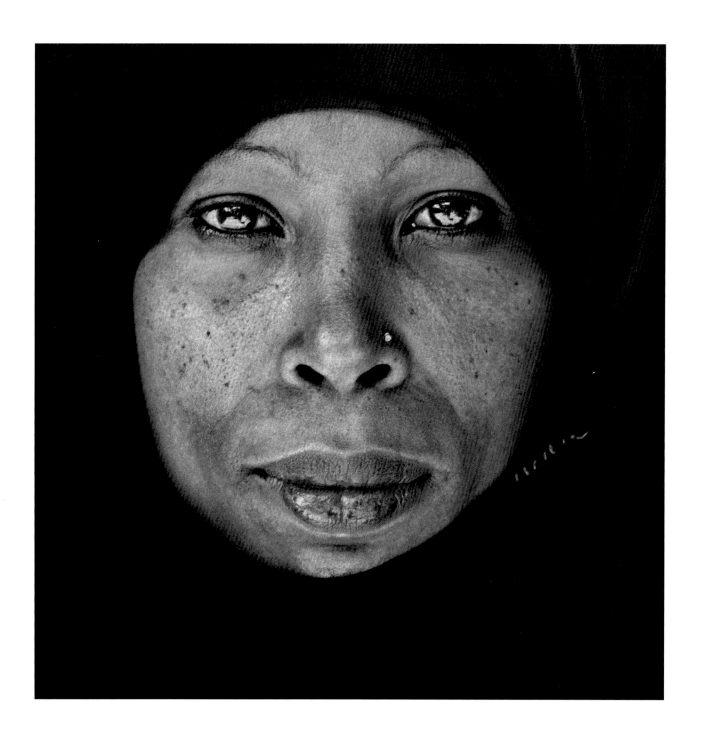

Lamu Woman, Kenya, 1985

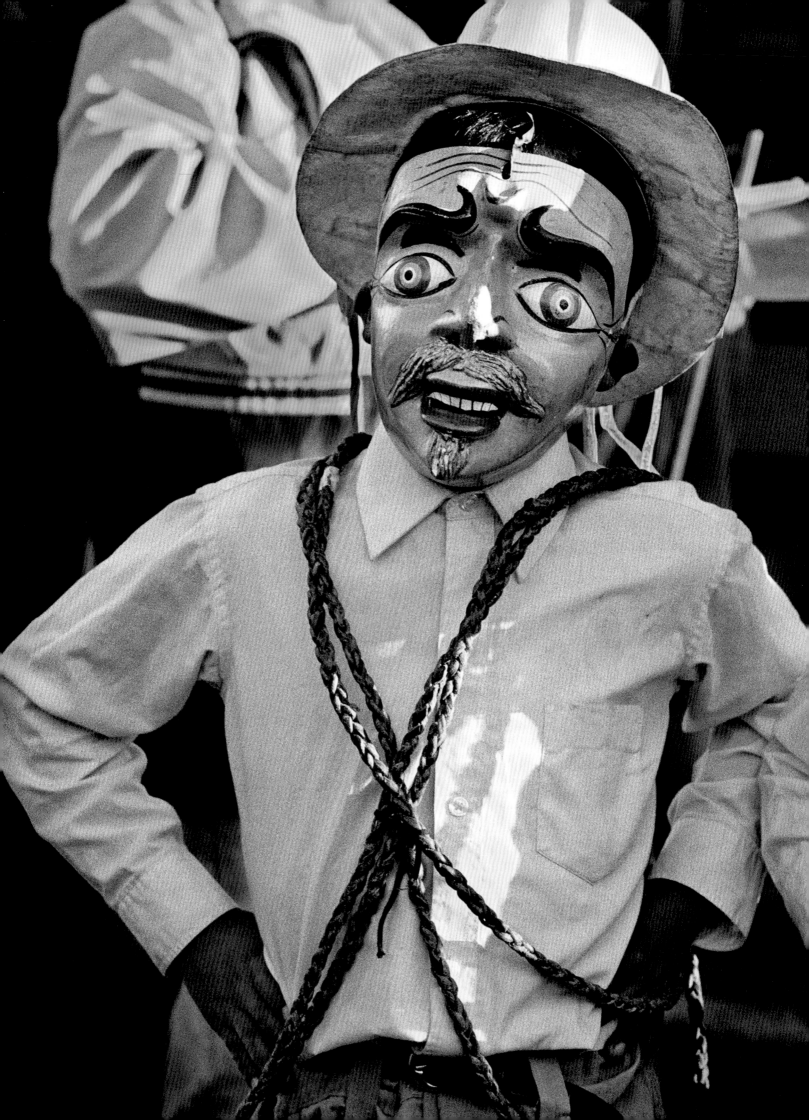

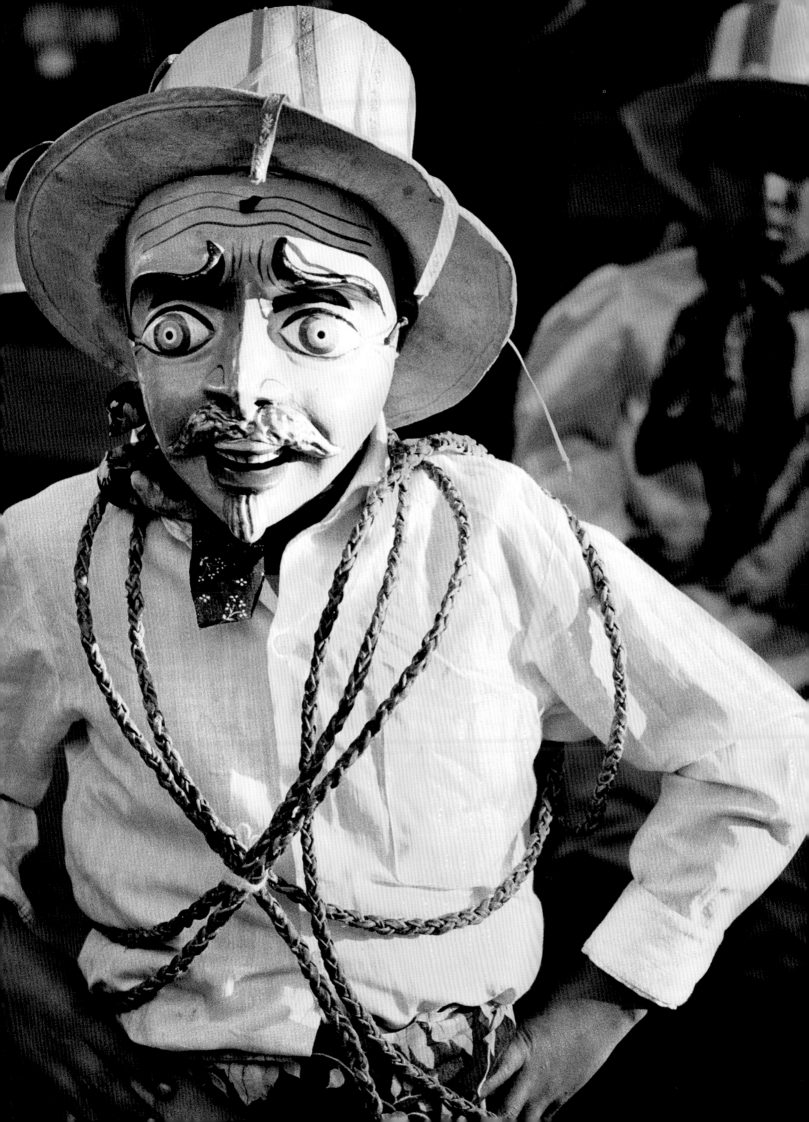

PREVIOUS SPREAD: *Festival Boys, Peru, 2006*
OPPOSITE PAGE: *Aboriginal Artist, Gathering of Elders,*
Onondaga Nation, New York, 1989

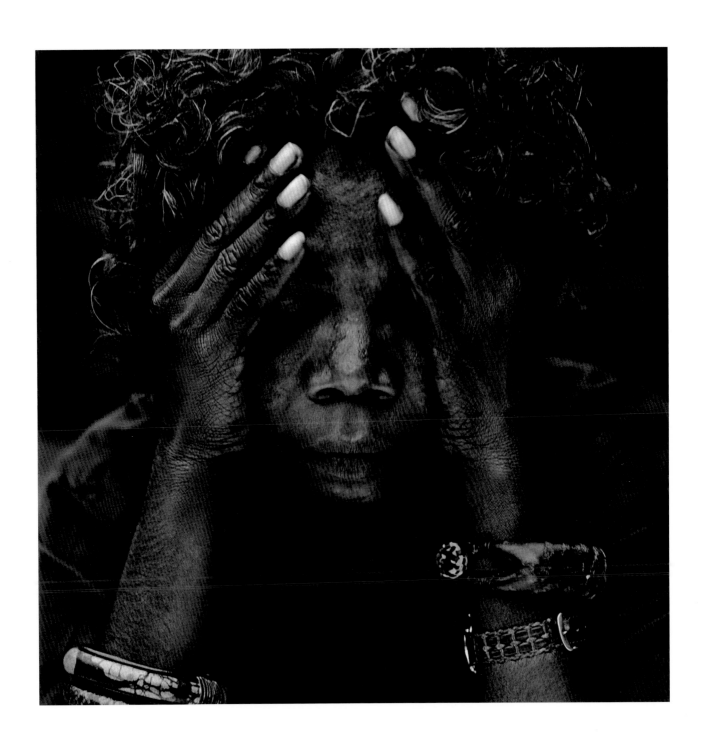

Dancer, Bali, 1988

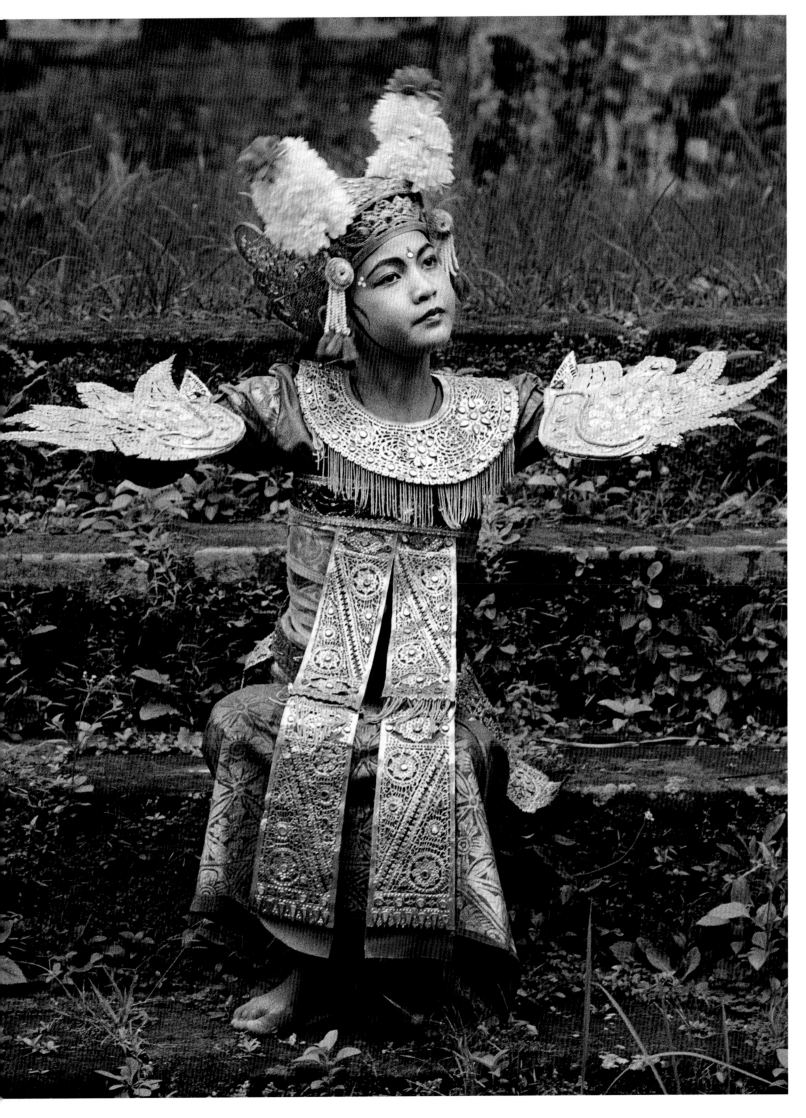

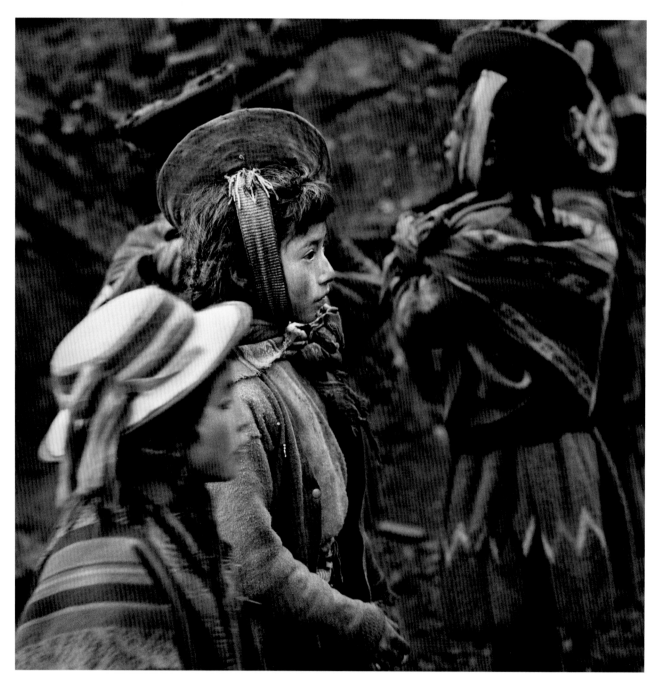

Quechua Schoolchildren Diptych, Peru, 2006

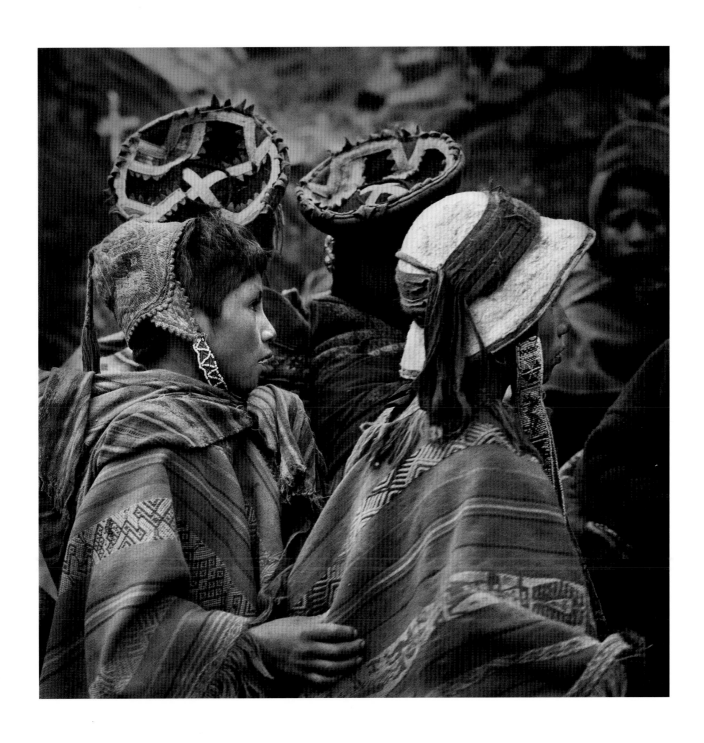

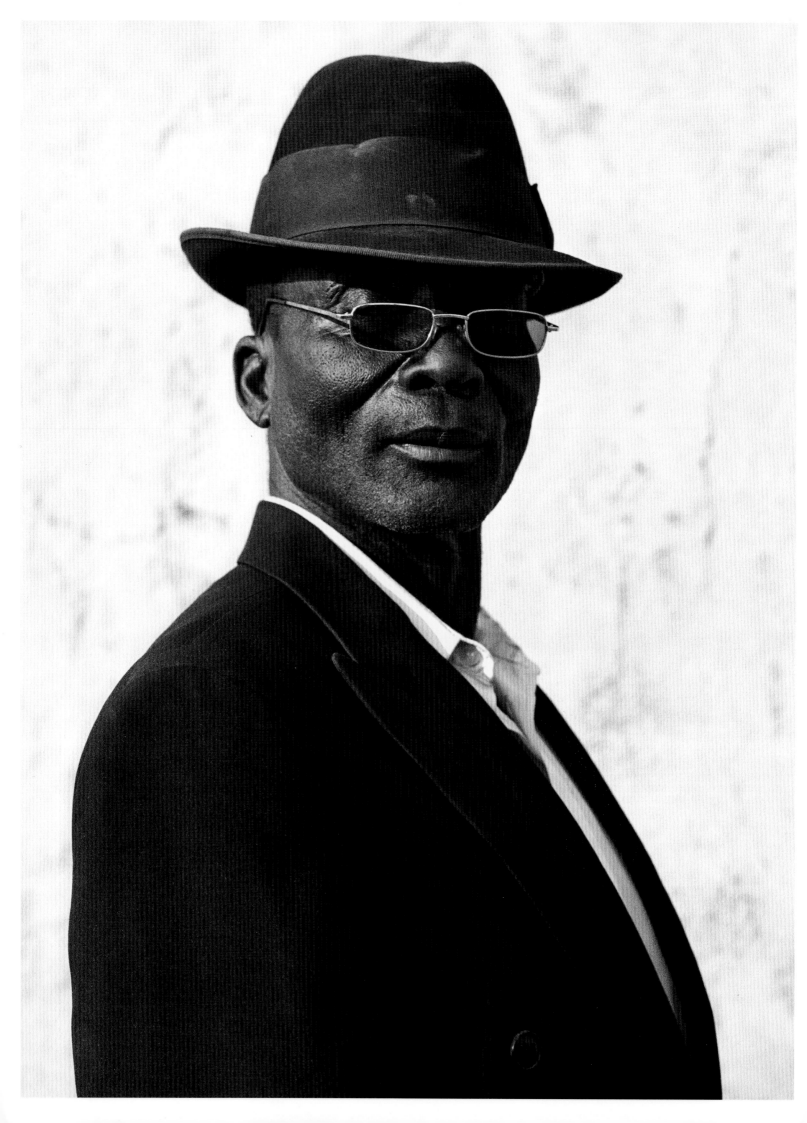

OPPOSITE PAGE: *Herero Man, Namibia, 2007*; THIS PAGE: *Herero Boy, Namibia, 2007*; *Herero Man, Namibia, 2007*; PAGE 30: *Herero Woman, Namibia, 2007*; PAGE 31: *Herero Woman, Namibia, 2007*

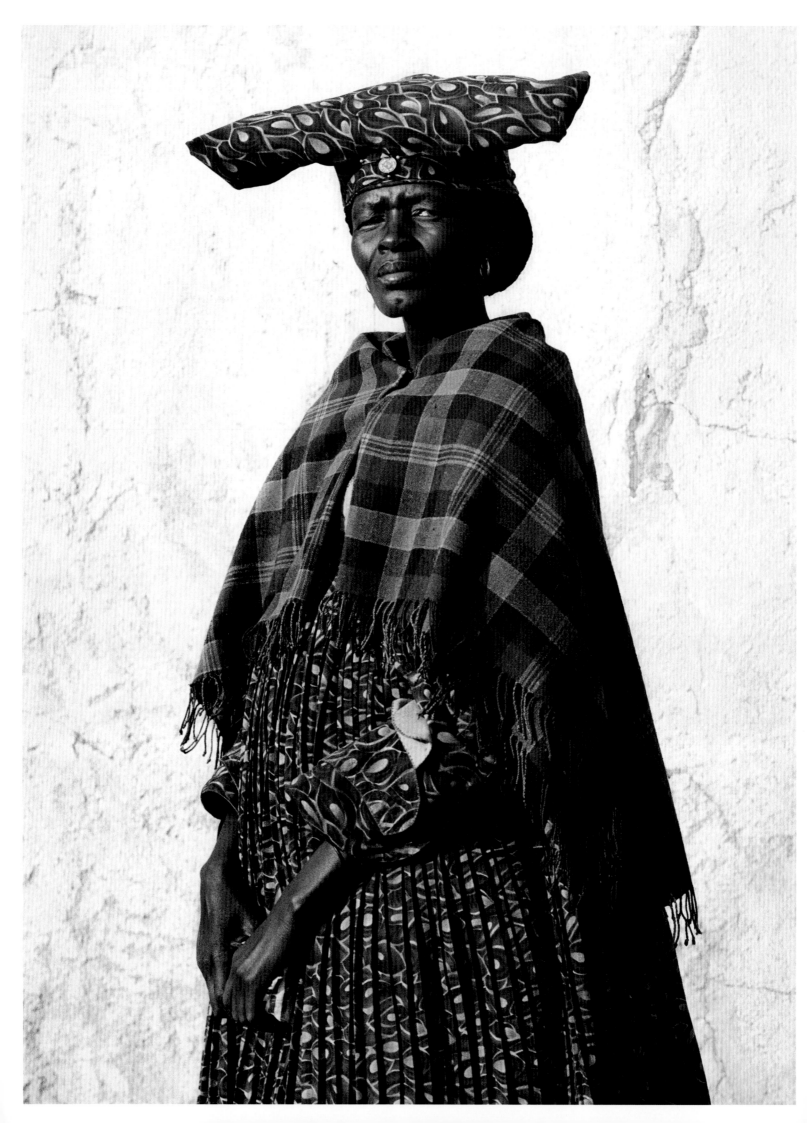

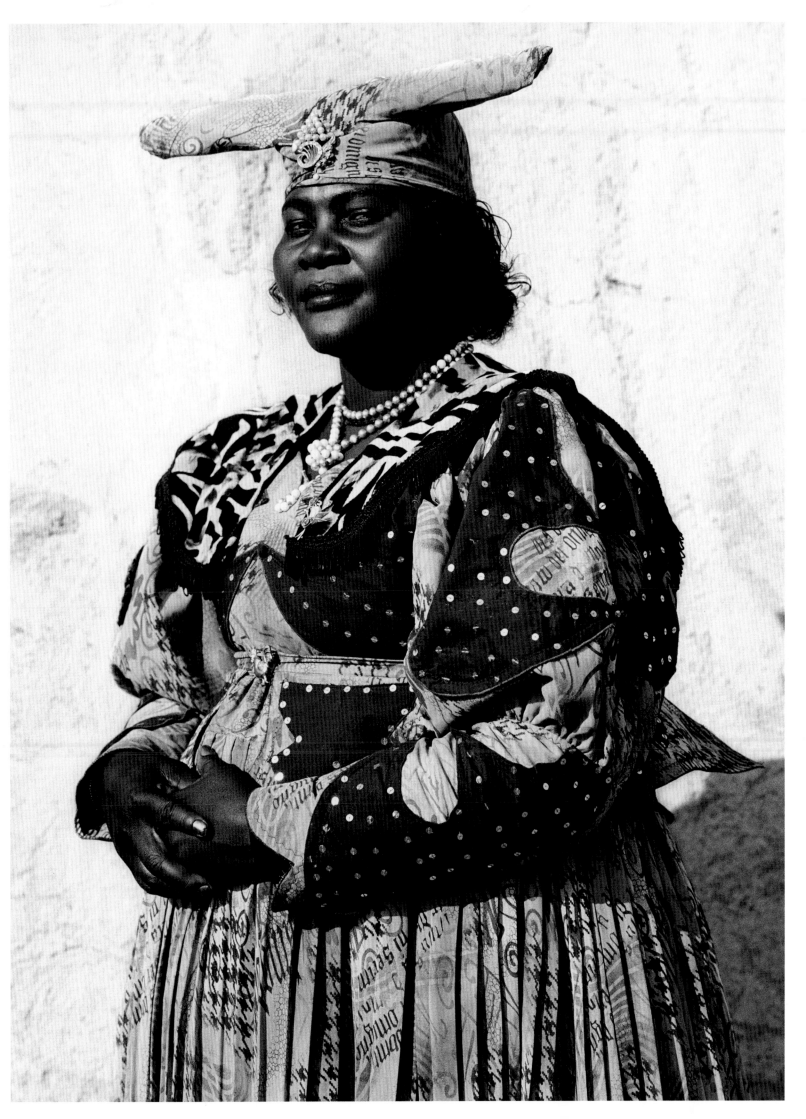

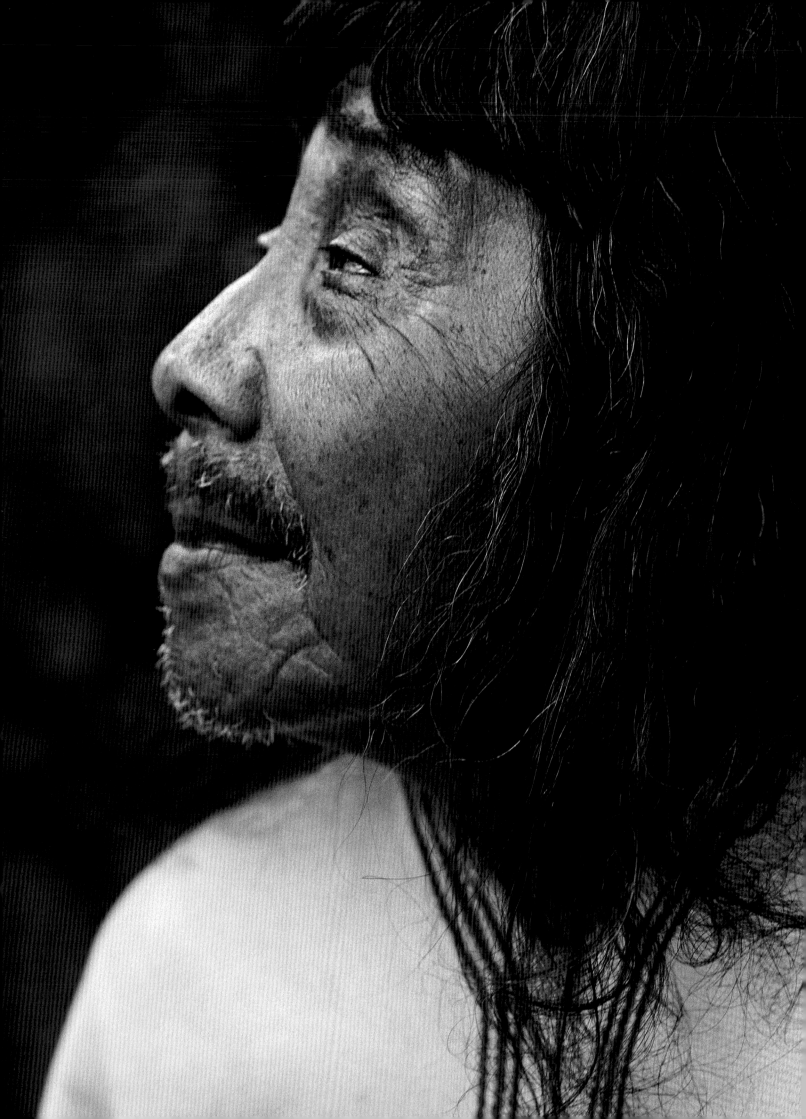

Lacandon Maya Shaman, Gathering of Elders,
Onondaga Nation, New York, 1989

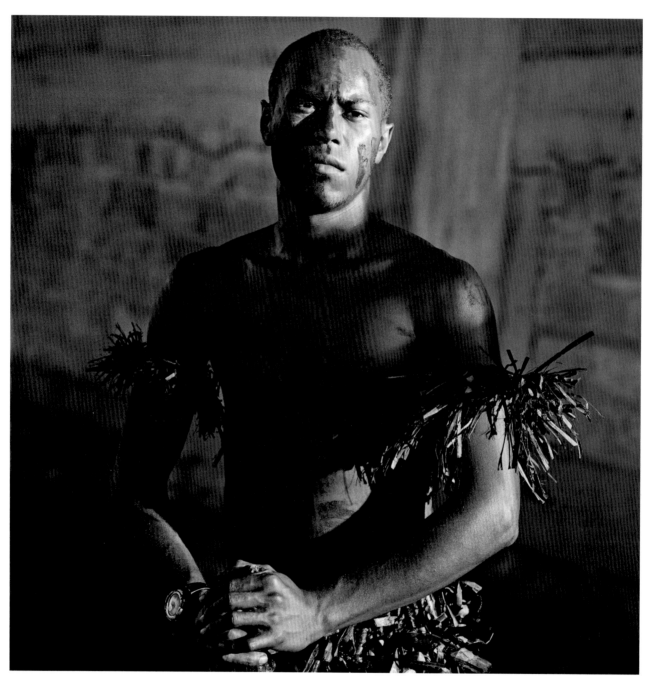

Chief's Warrior, Fiji, 2008

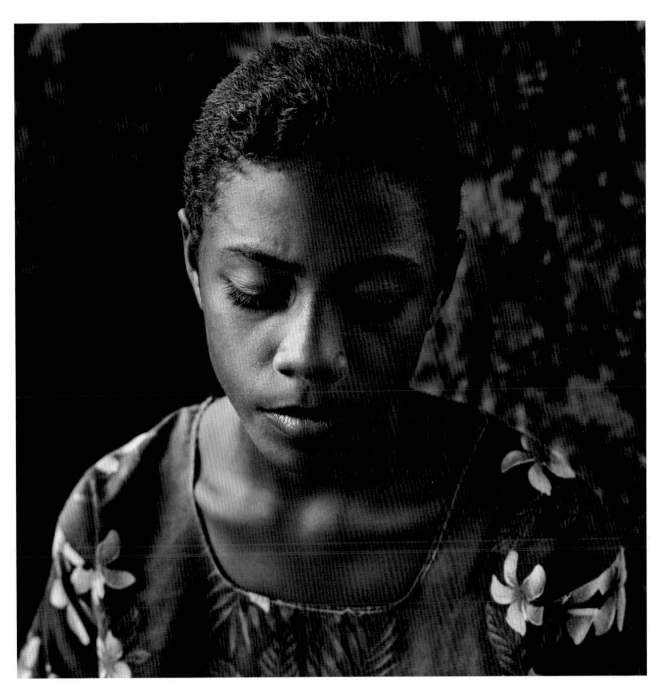

Teenage Girl, Fiji, 2008

Ovazemba Teenage Girls, Namibia, 2007

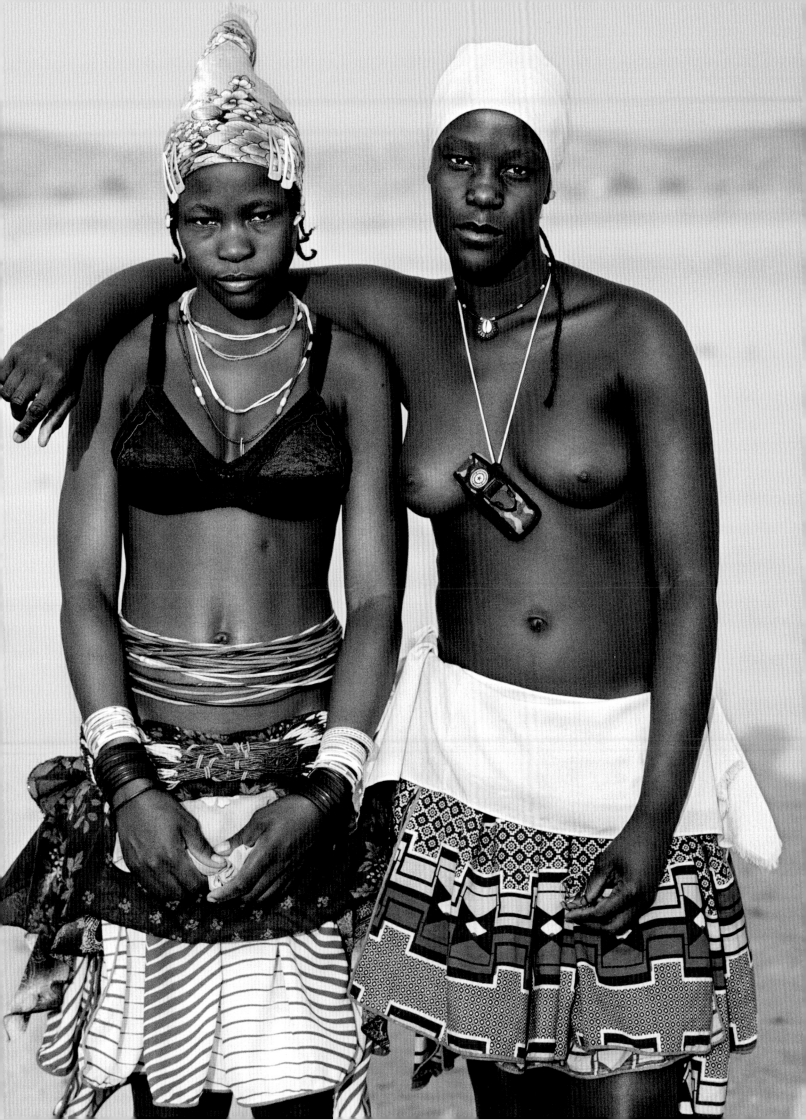

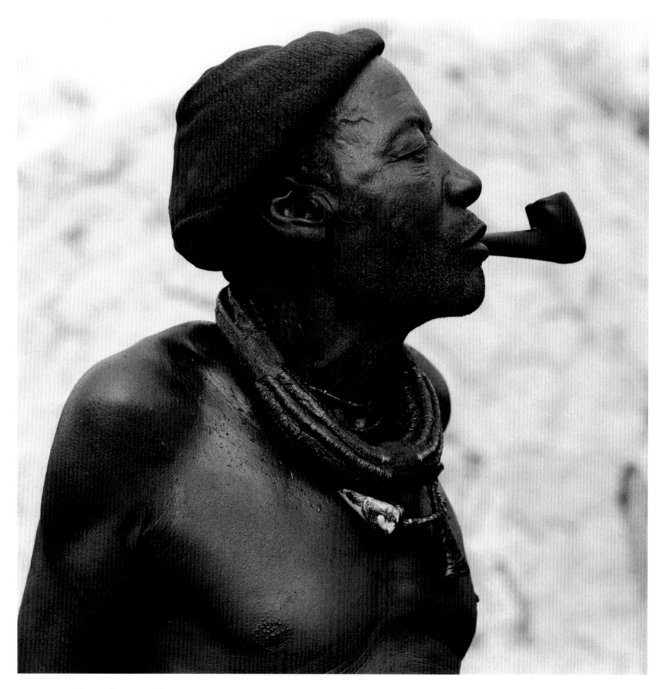

THIS PAGE: *Himba Headman, Namibia, 2007;* OPPOSITE PAGE: *Himba Teenage Girl, Namibia, 2007*

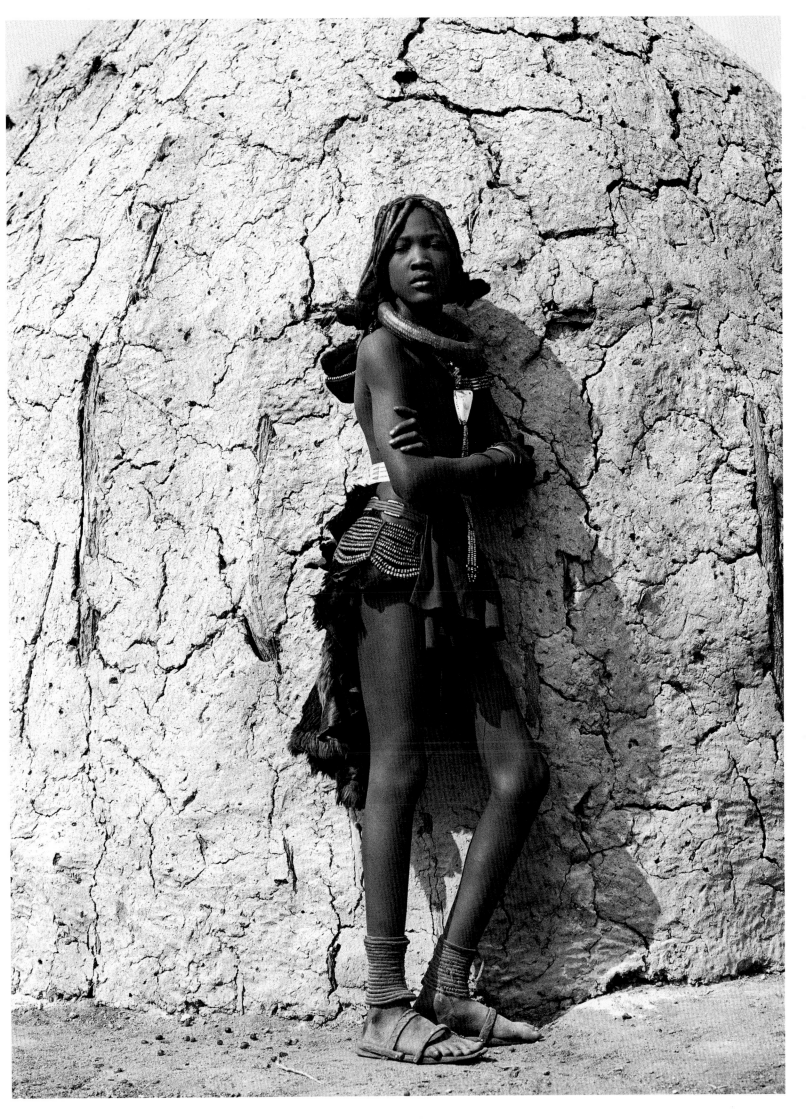

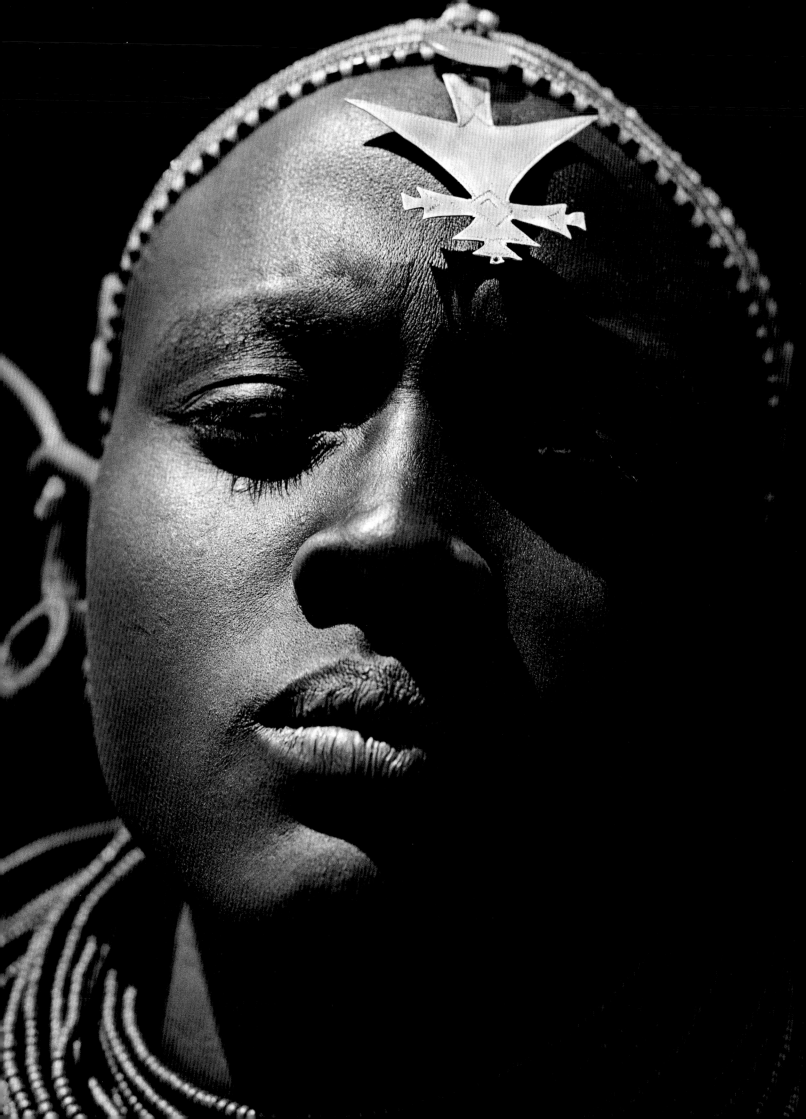

Samburu Girl, Kenya, 1985

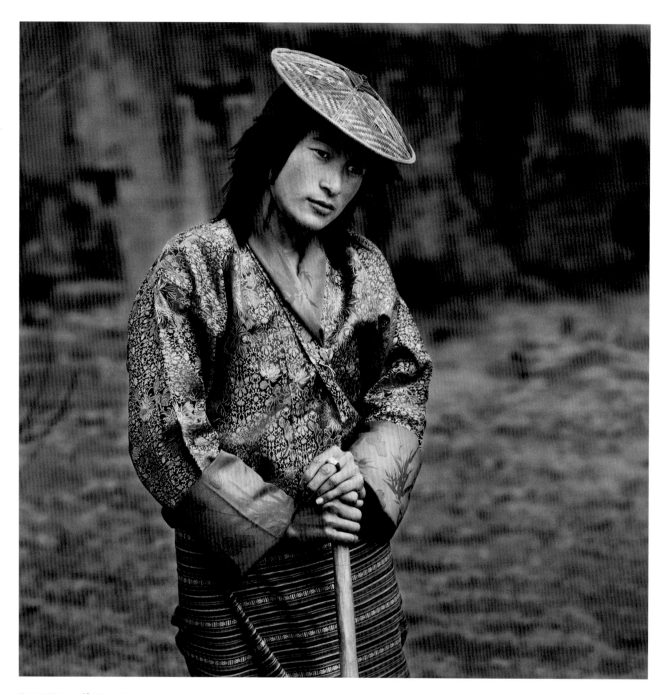

Young Woman, Bhutan, 2010

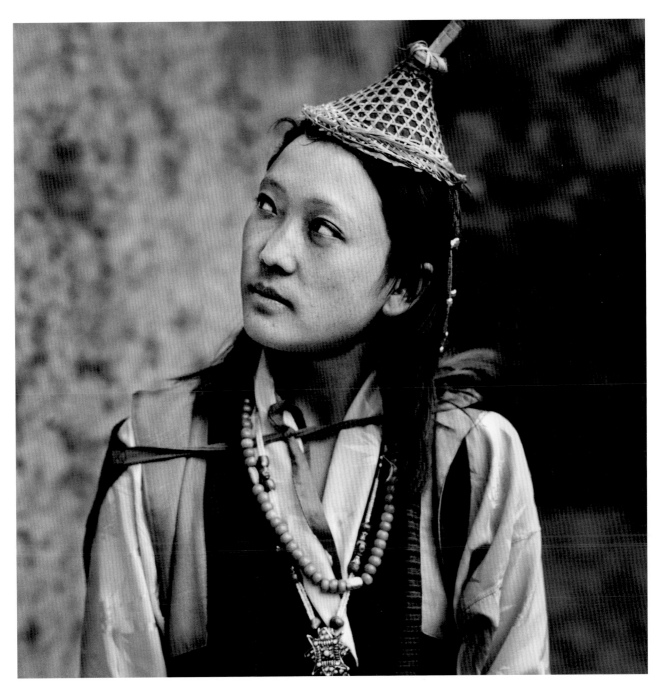

Dancer, Bhutan, 2010

Goba Dancer, Zambia, 2007

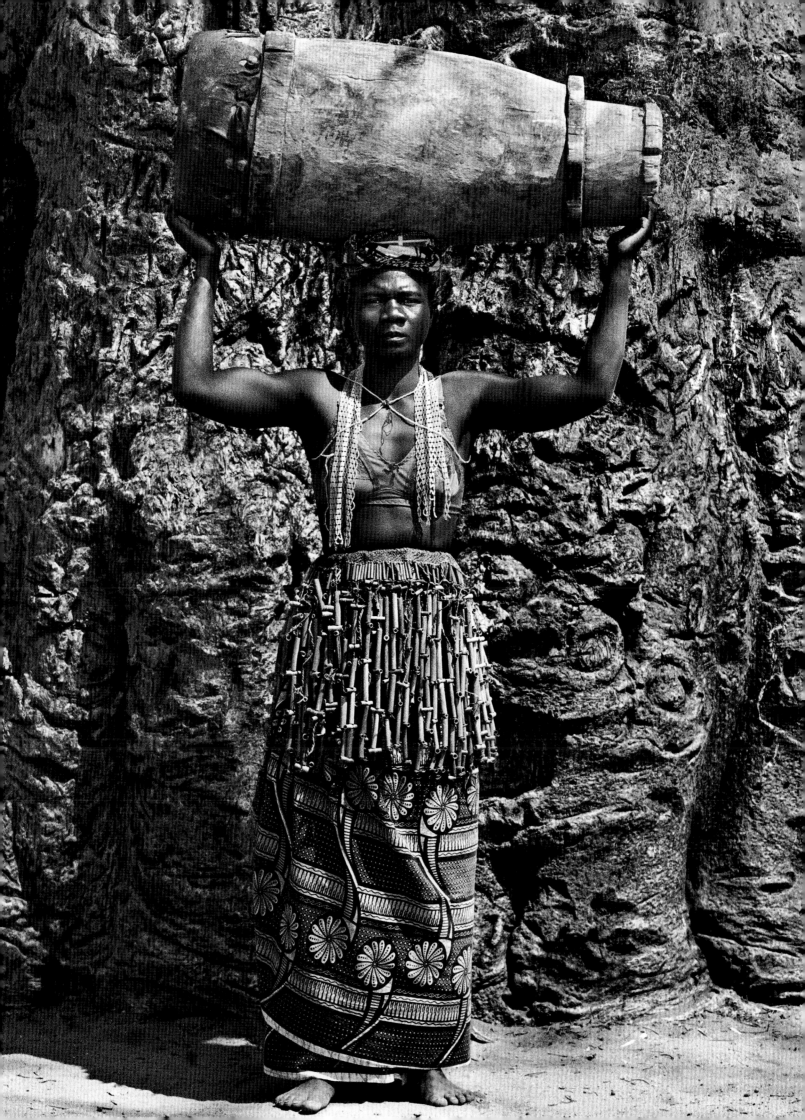

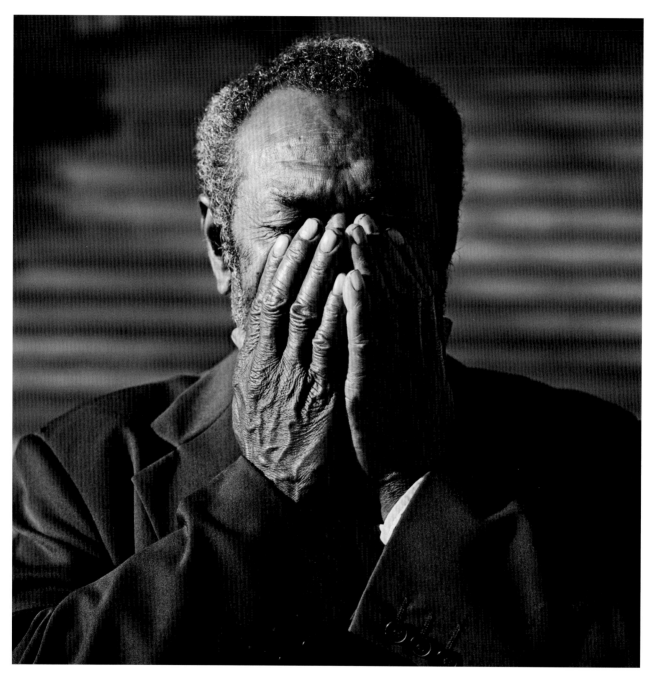

THIS PAGE: *Methodist Church Congregant, Fiji, 2008*; OPPOSITE PAGE: *Methodist Preacher's Wife, Fiji, 2008*

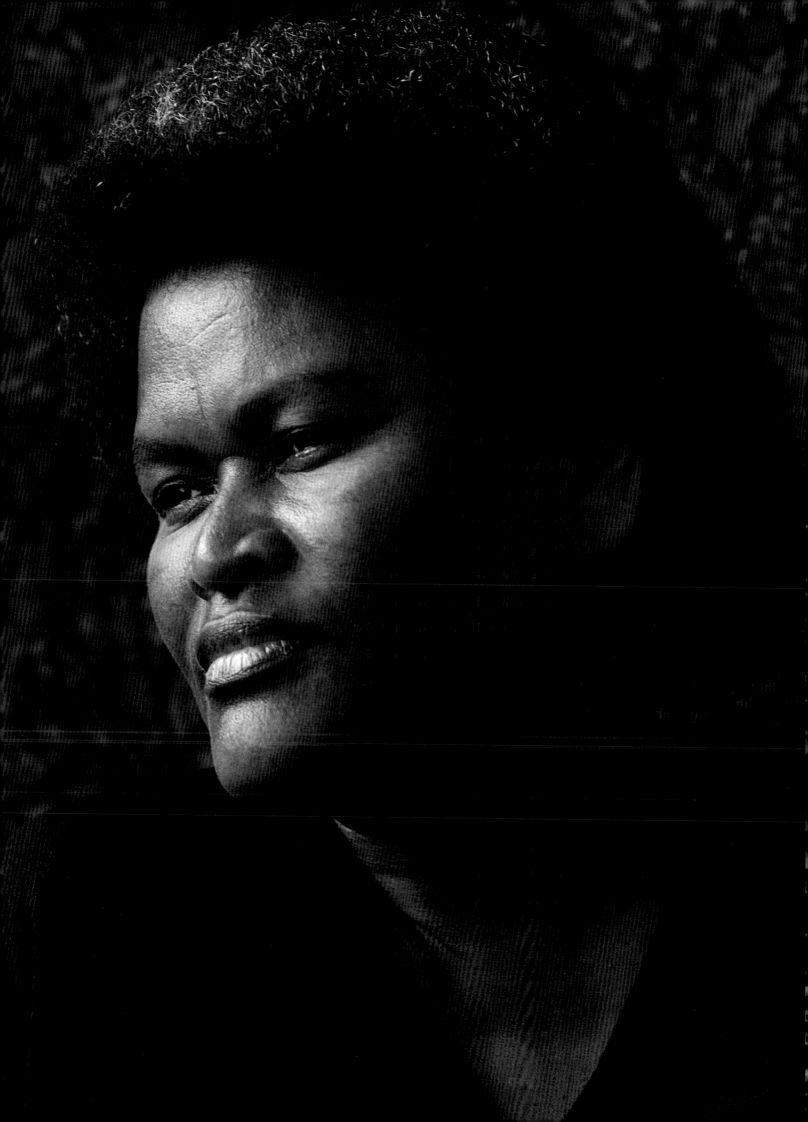

Zinacantan Maya Elders, Chiapas, Mexico, 2004

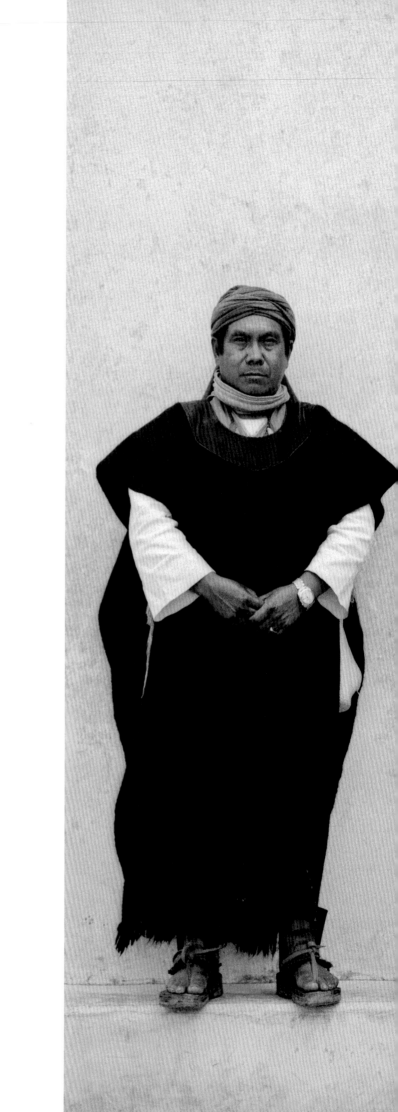

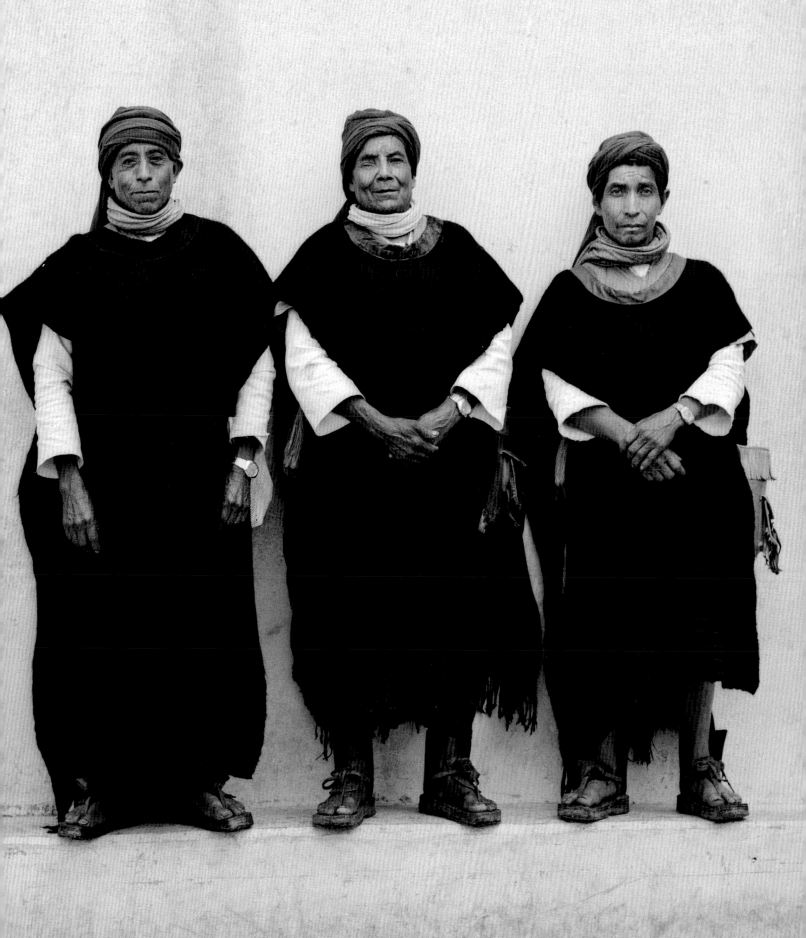

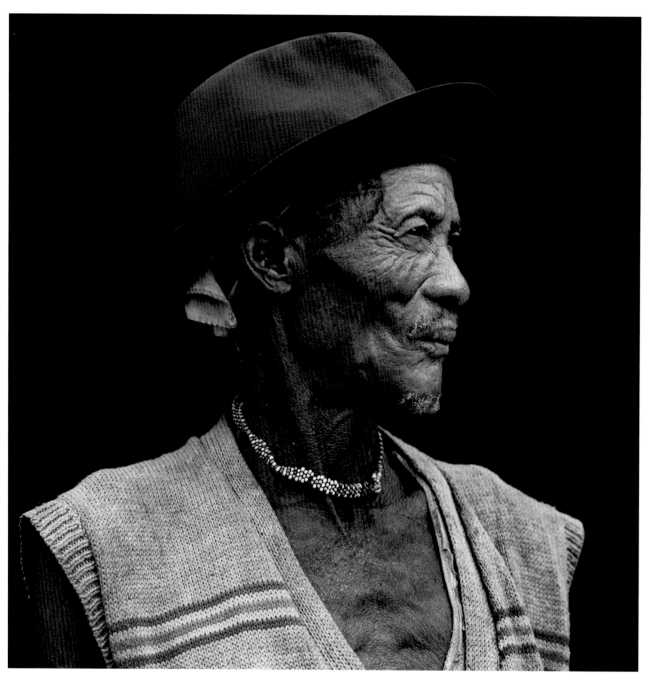

San Bushman Healer, Botswana, 2009

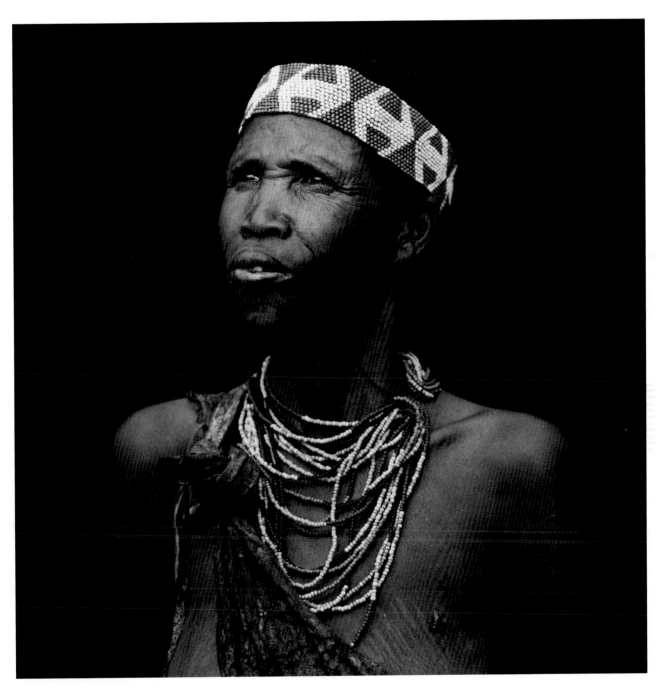

San Bushman Dancer, Botswana, 2009

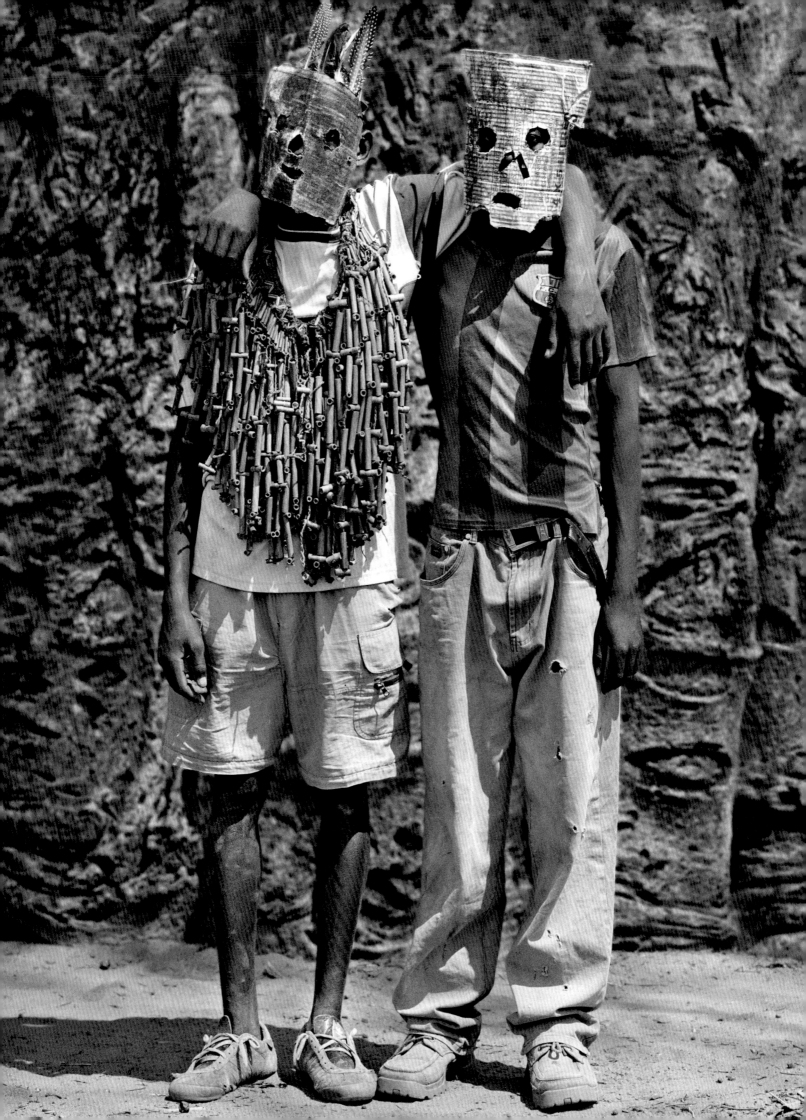

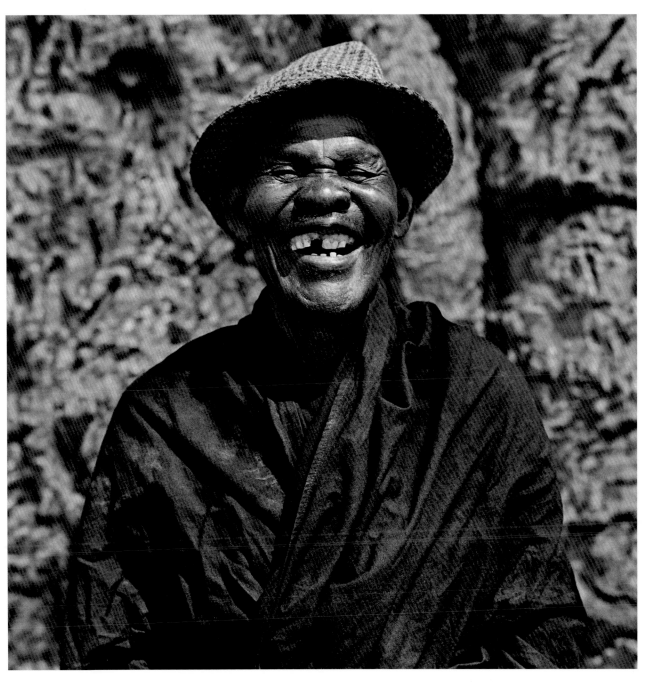

OPPOSITE PAGE: *Goba Boys, Zambia, 2007;* THIS PAGE: *Goba Headman, Zambia, 2007;*

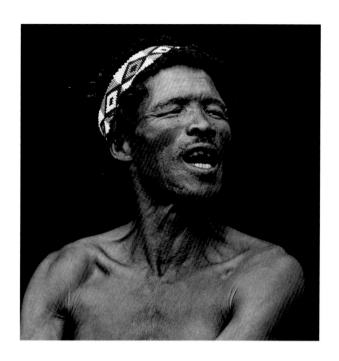

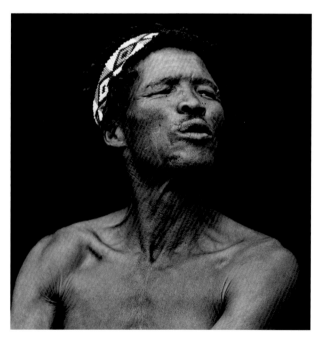

TOP: *San Bushman Hunter Singing, Botswana, 2009*
ABOVE: *San Bushman Hunter Singing, Botswana, 2009*
OPPOSITE PAGE: *San Bushman Hunter, Botswana, 2009*

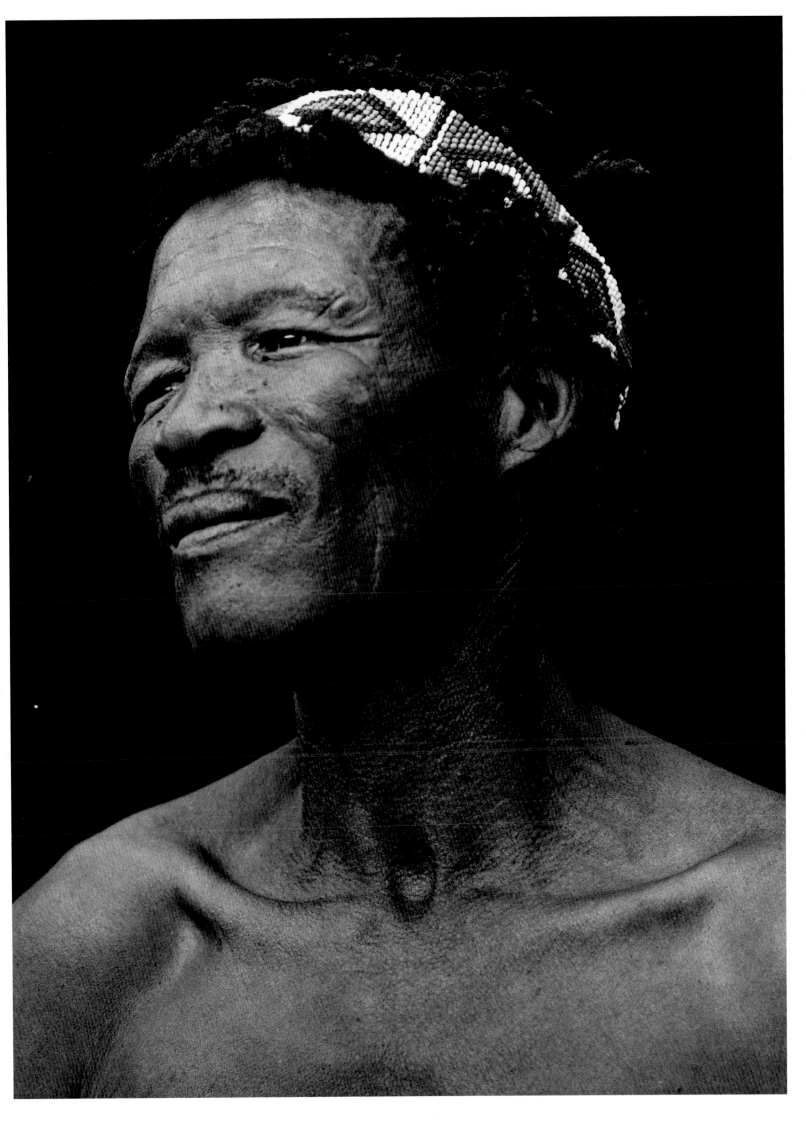

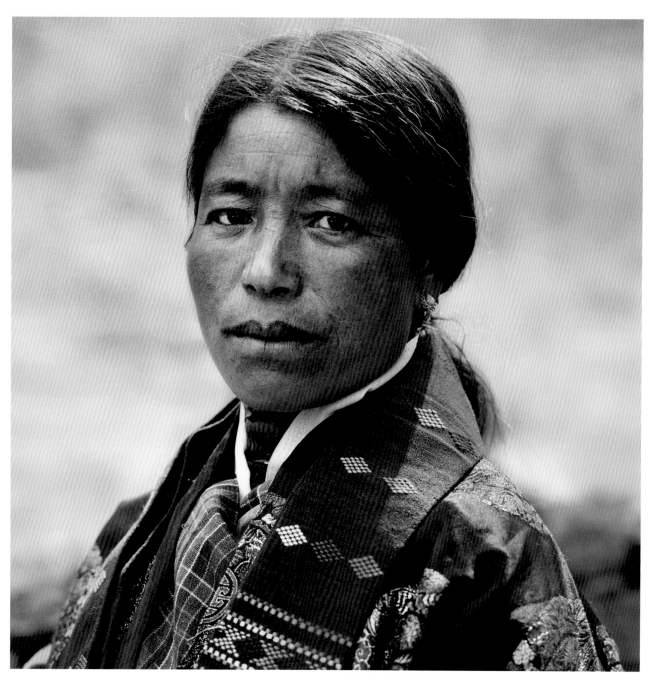

THIS PAGE: *Farmer, Bhutan, 2010*; OPPOSITE PAGE: *Schoolgirl, Bhutan, 2010*

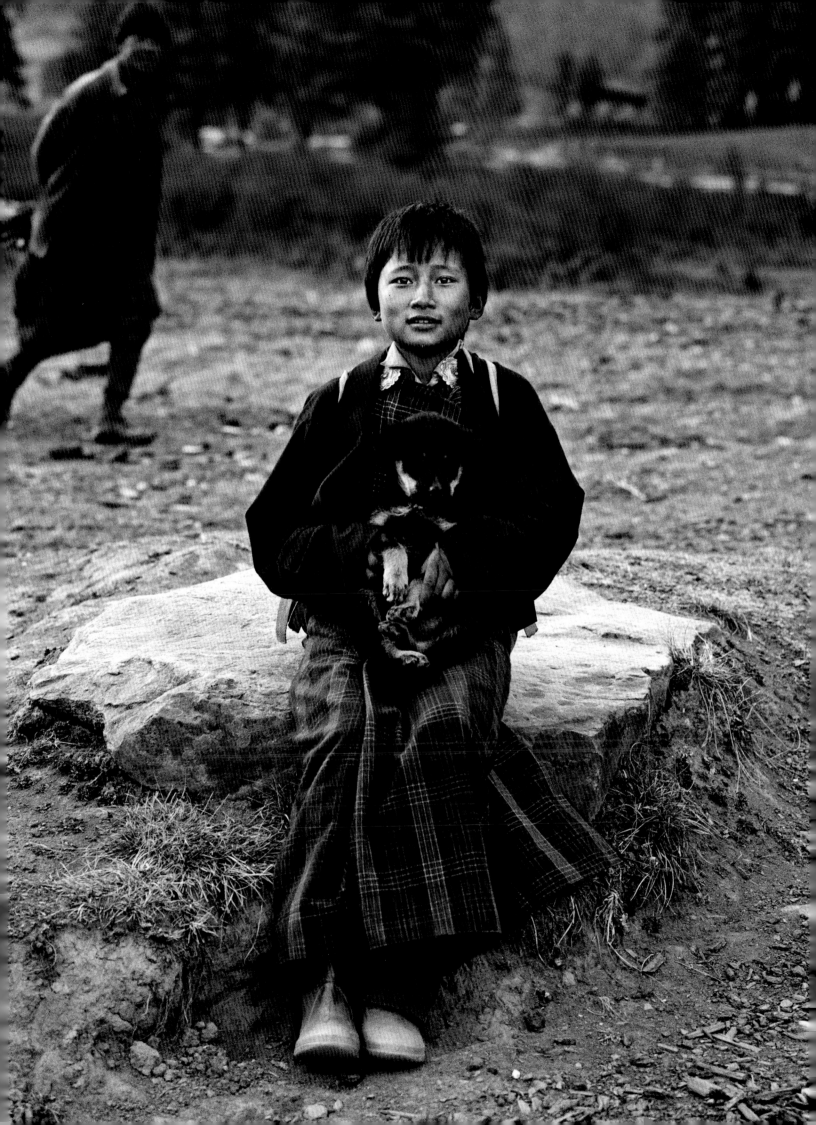

Flour Mill Worker, Haiti, 1983

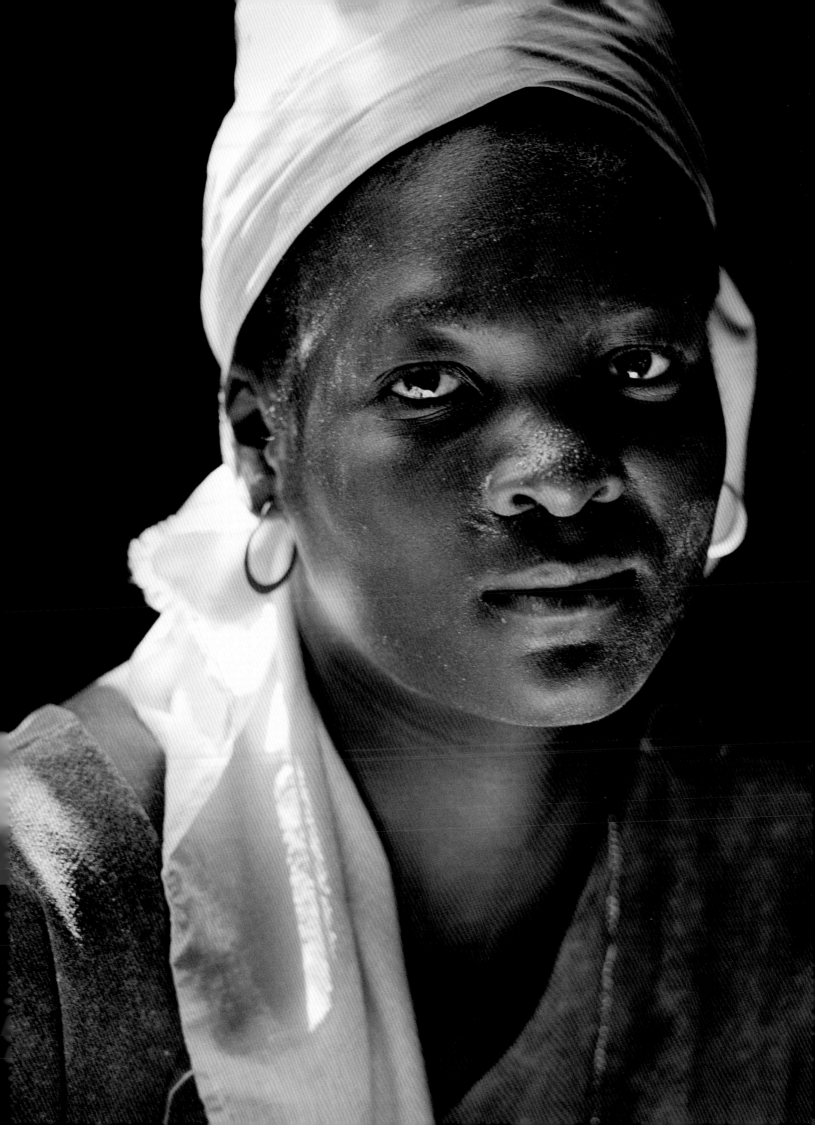

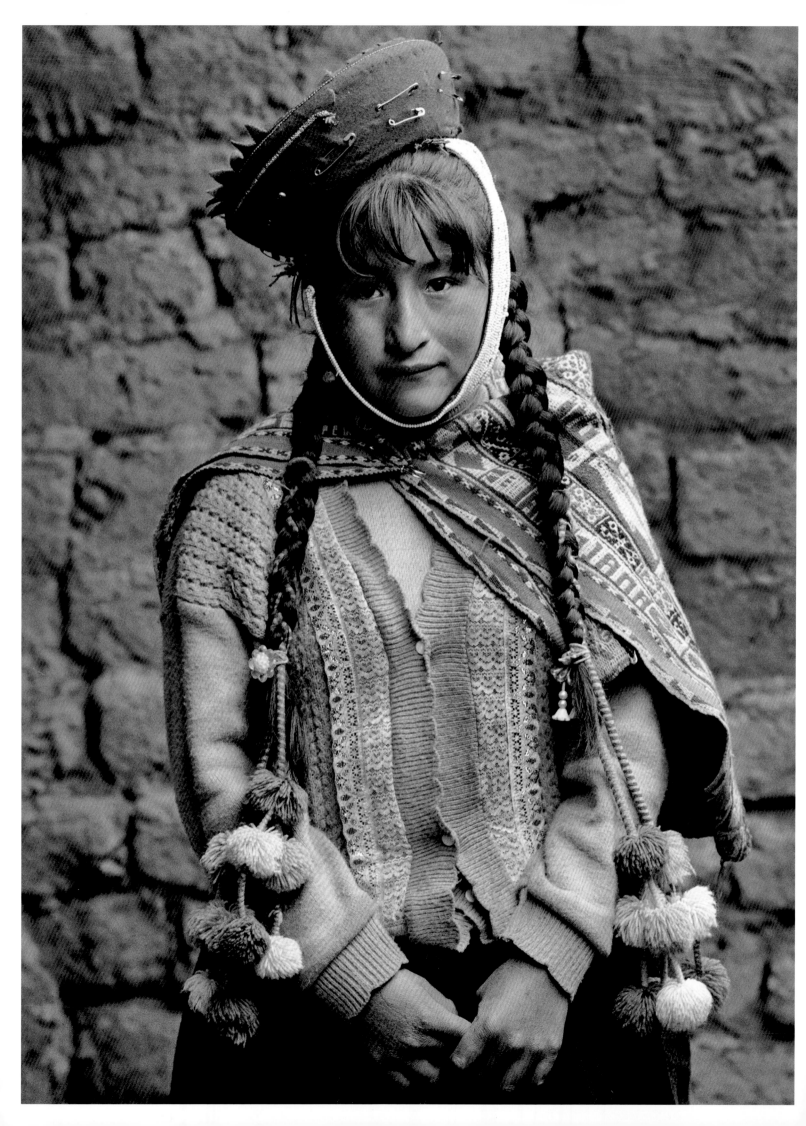

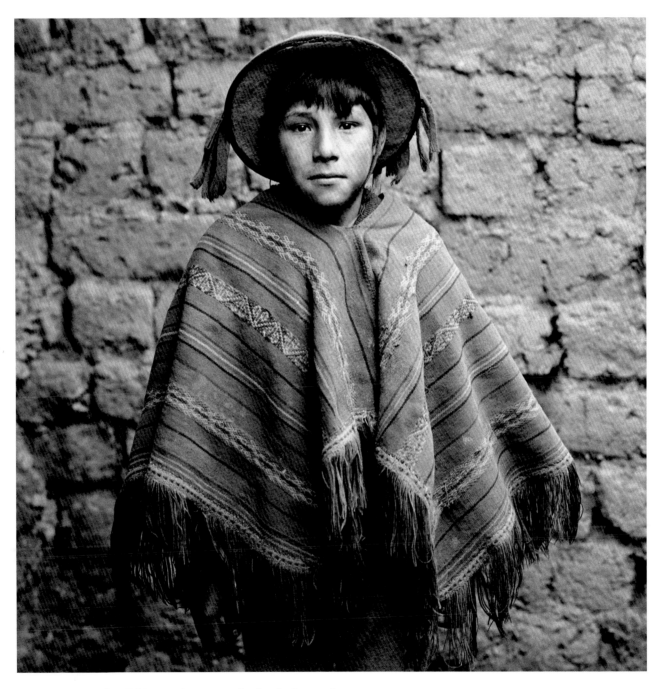

OPPOSITE PAGE: *Quechua Girl, Peru, 2006;* THIS PAGE: *Quechua Boy, Peru, 2006*

Campbell River Indian Band Teenage Girl, Canada, 2008

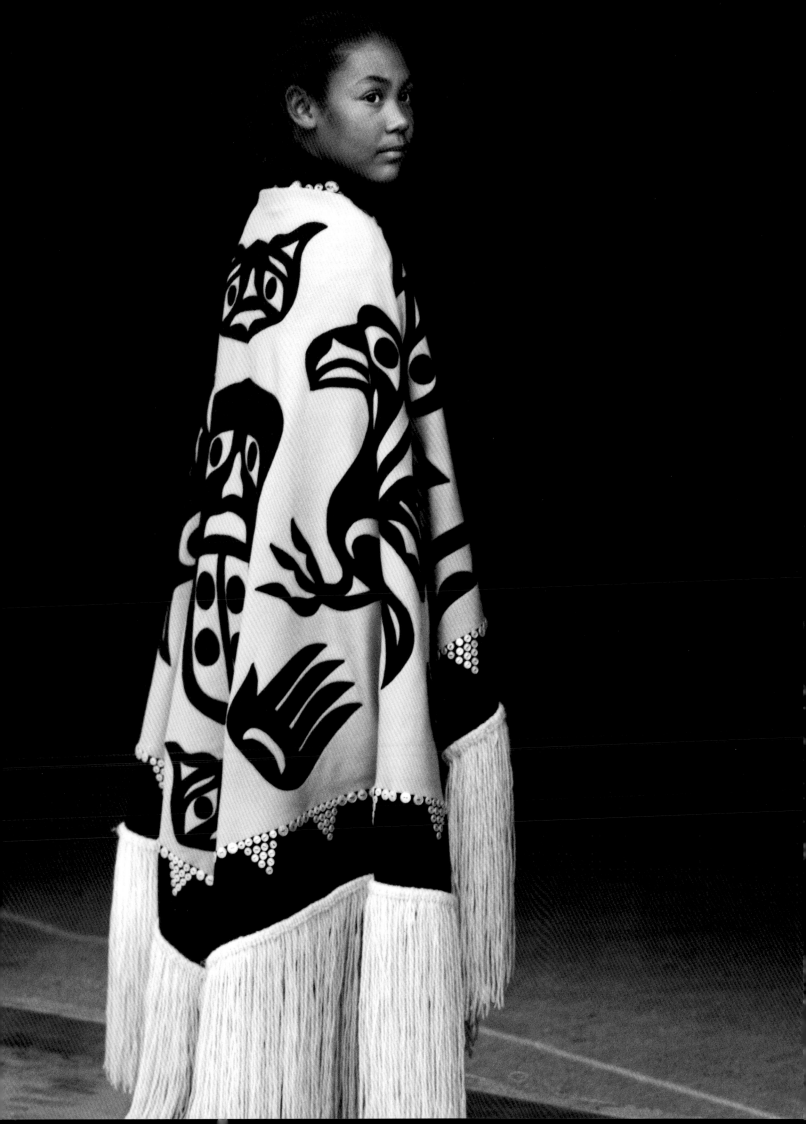

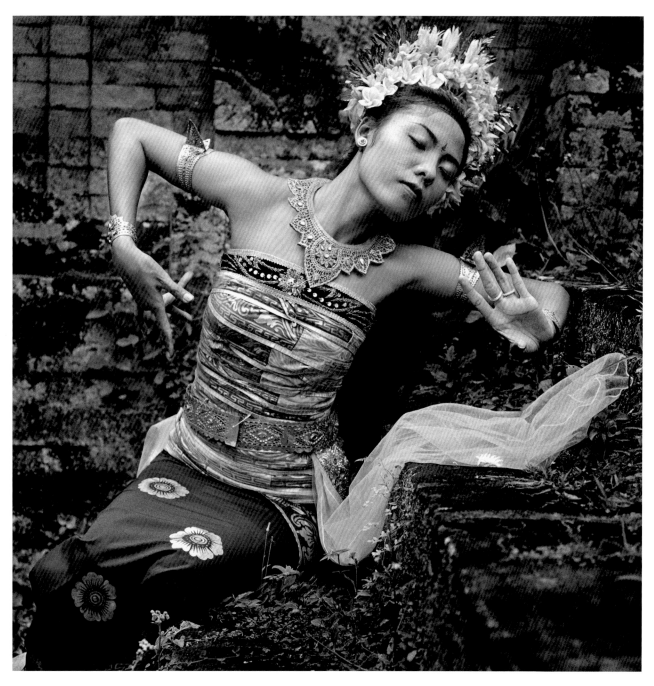

Dancer, Bali, 1988

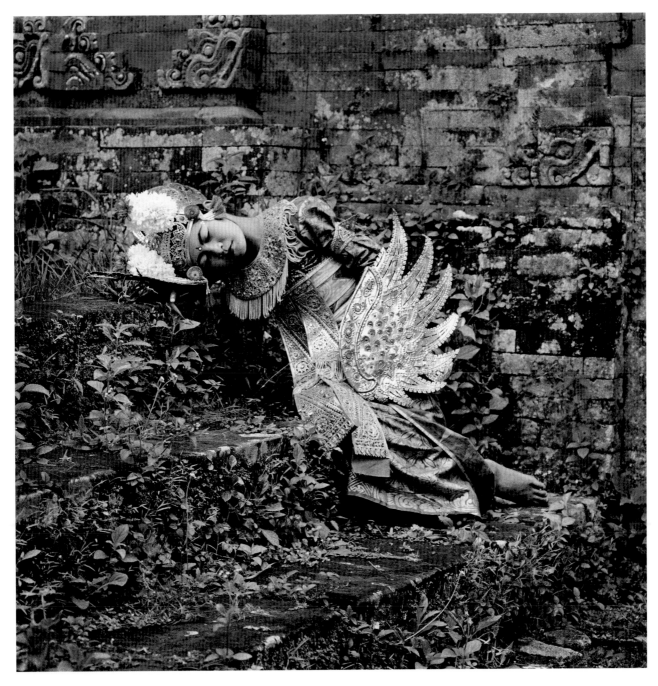

Dancer, Bali, 1988

Dancers, Bhutan, 2010

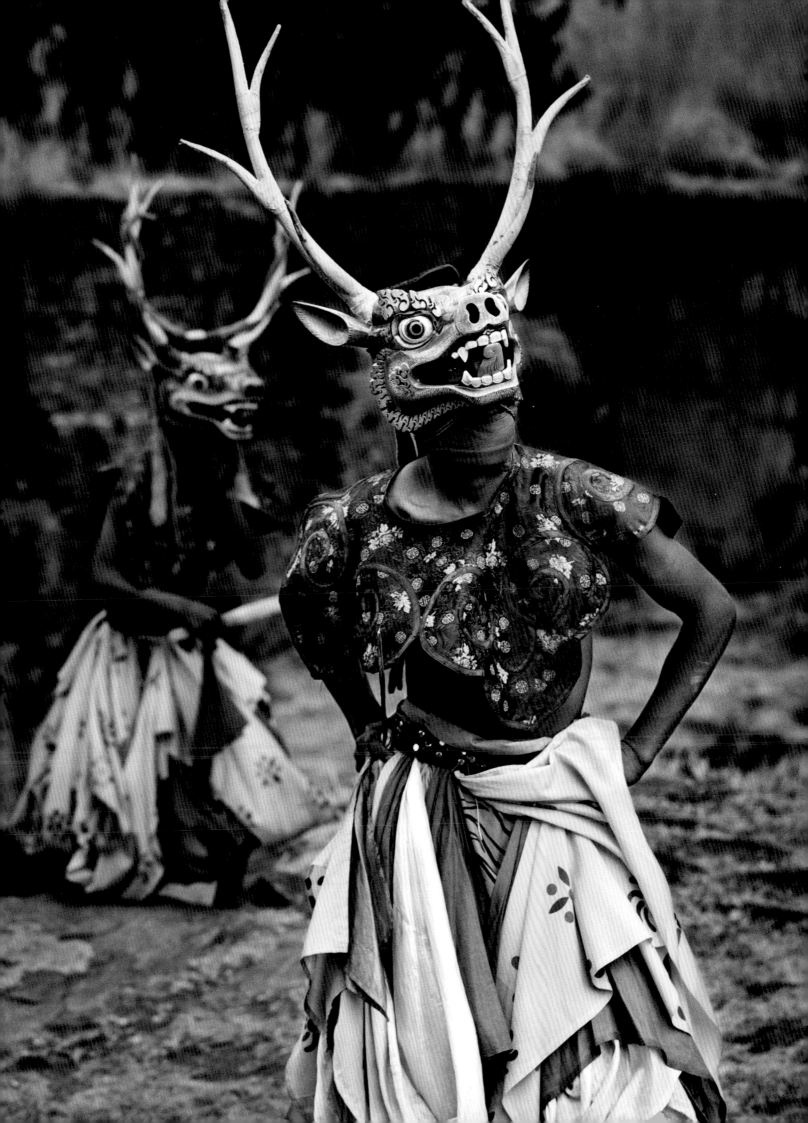

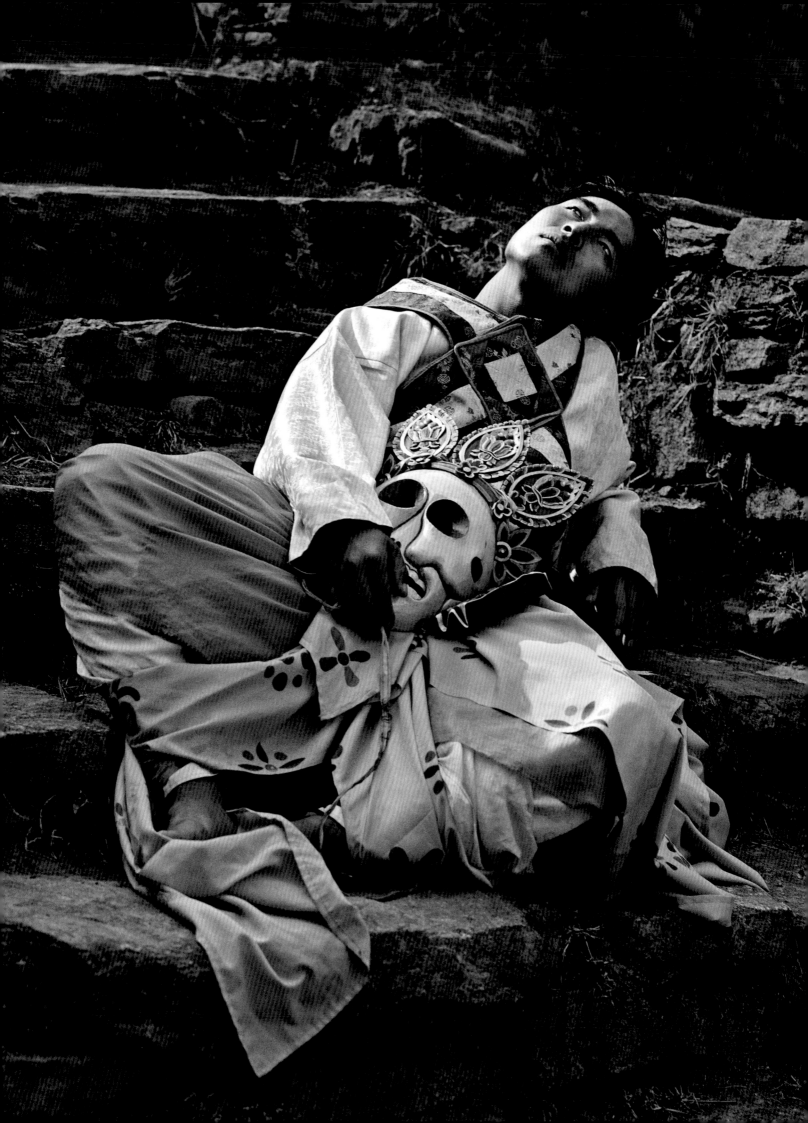

Dancer, Bhutan, 2010

Woman with Pipe, Haiti, 1983

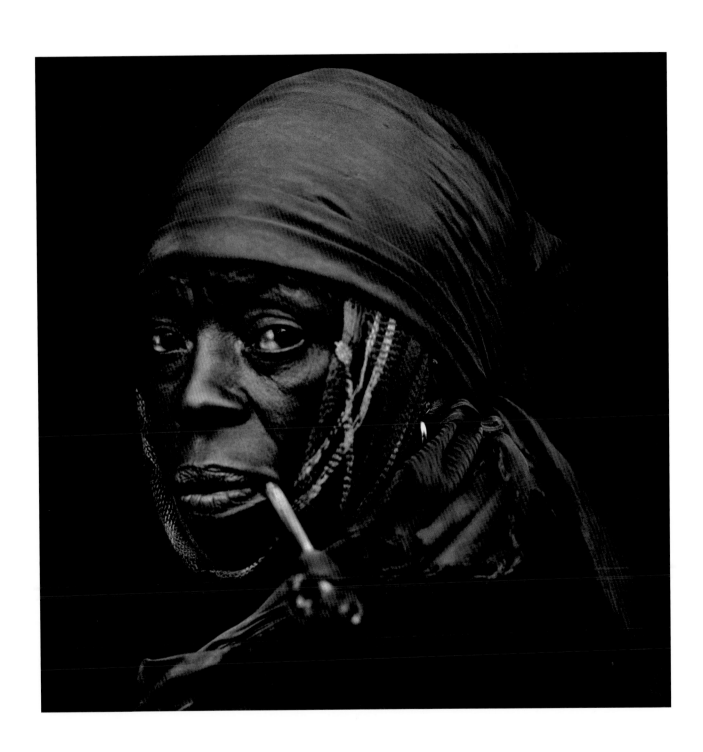

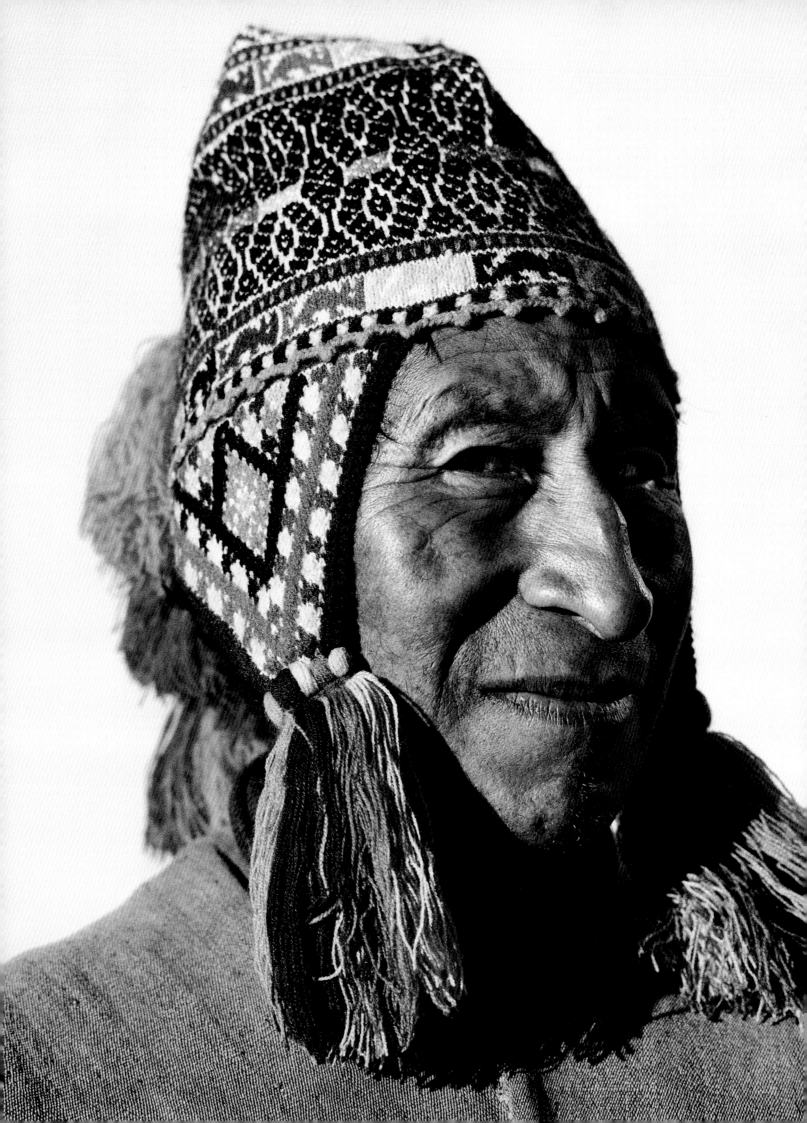

Qero Pakko Healer, Peru, 2006

Njemps Girlfriends, Kenya, 1985

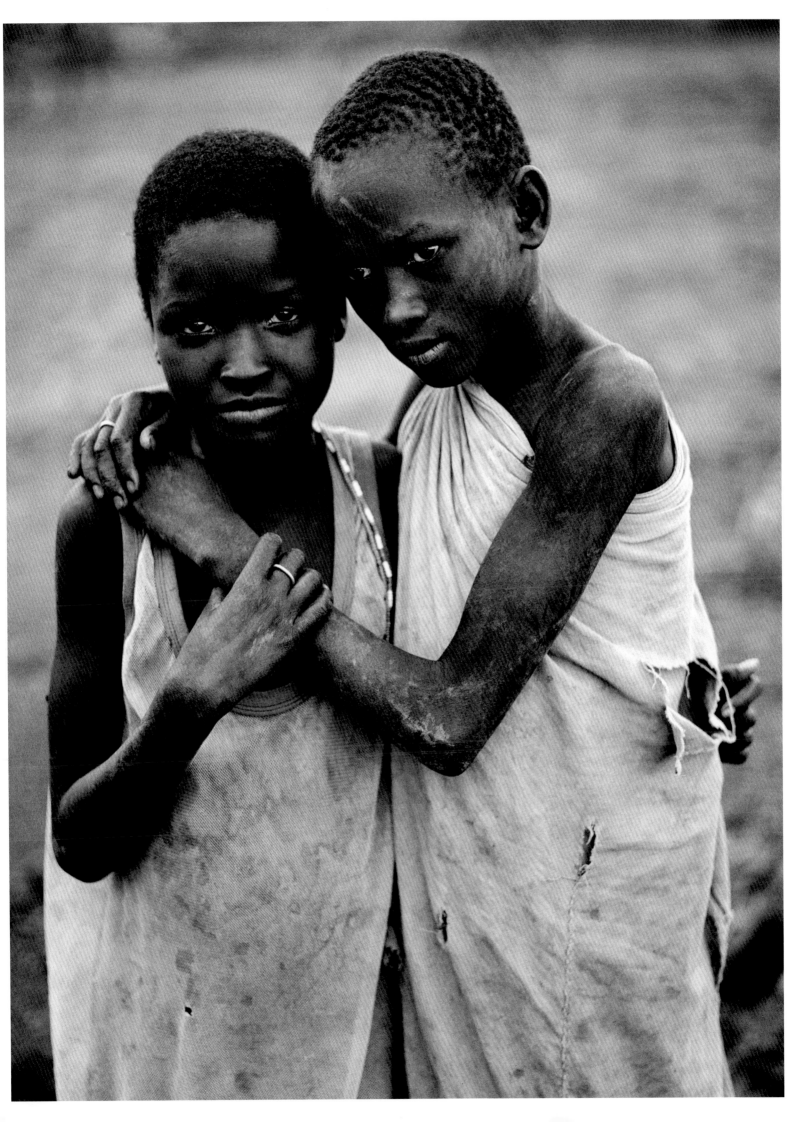

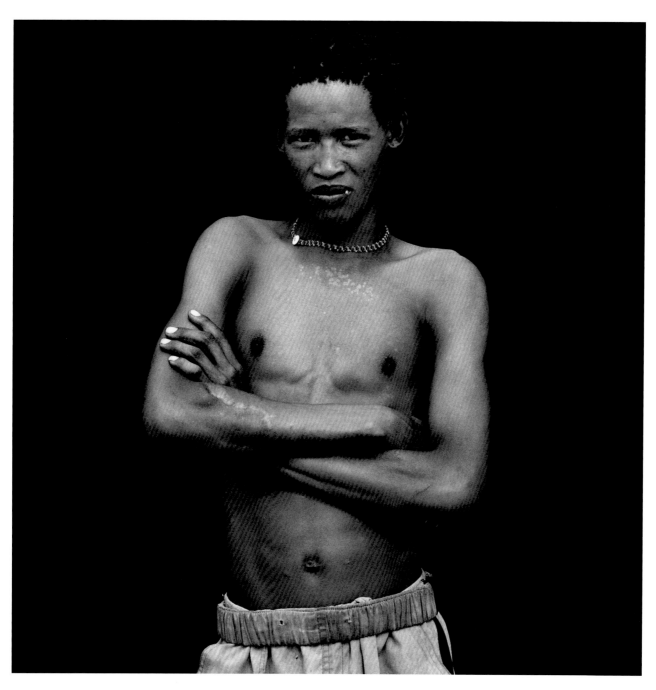

THIS PAGE: *San Bushman Young Man, Botswana, 2009*; OPPOSITE PAGE: *San Bushman Young Man, Botswana, 2009*

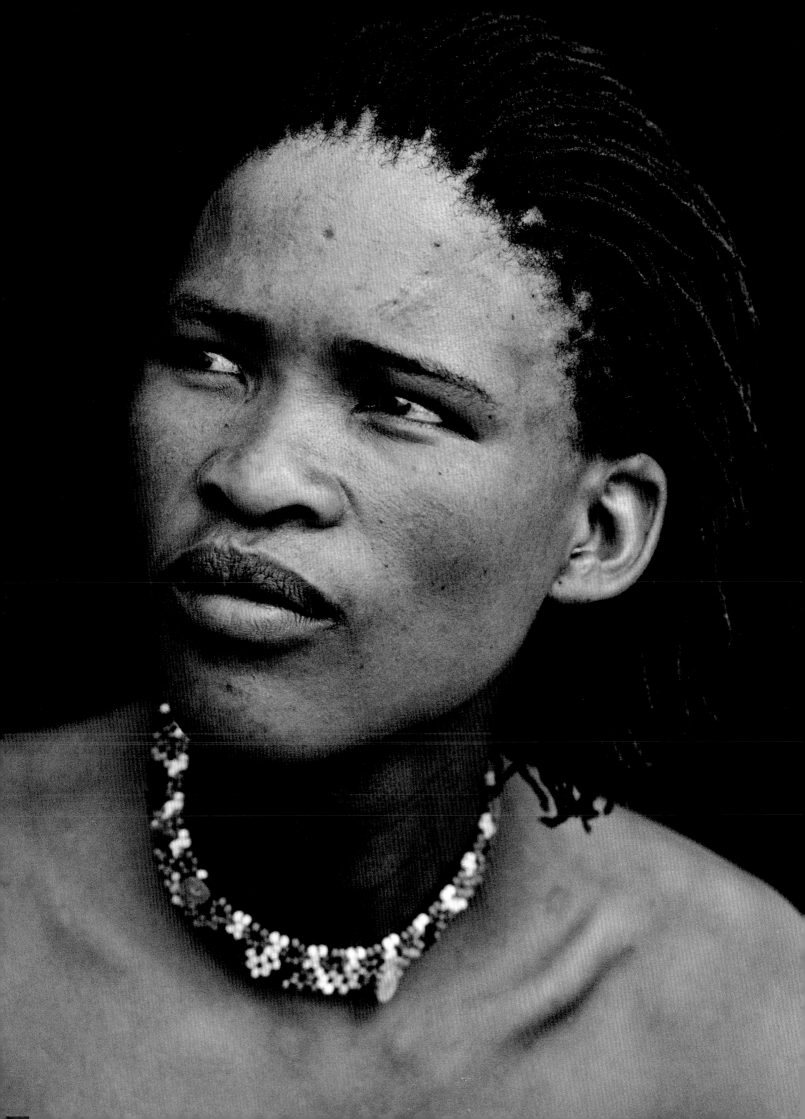

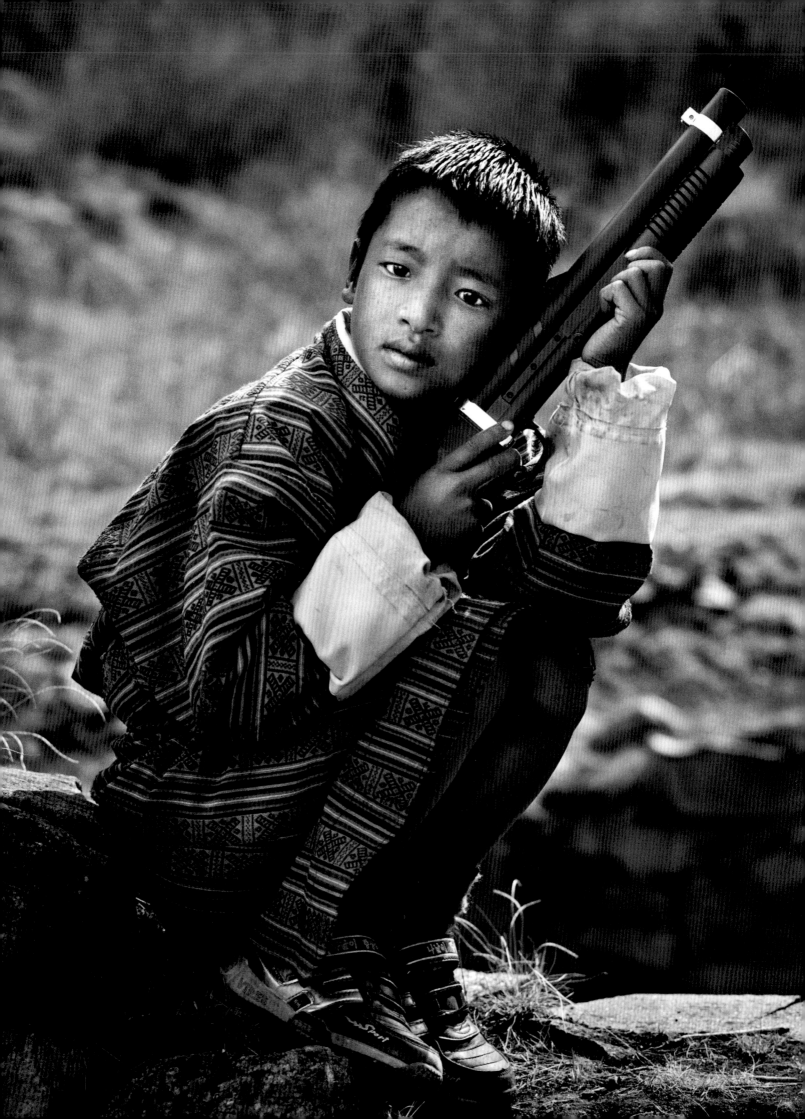

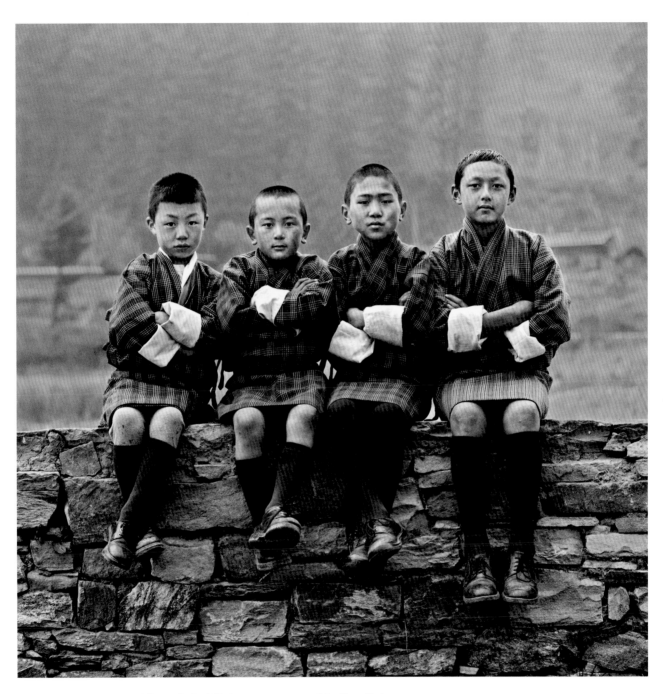

OPPOSITE PAGE: *Young Boy at Religious Festival, Bhutan, 2010*; THIS PAGE: *Schoolboys, Bhutan, 2010*

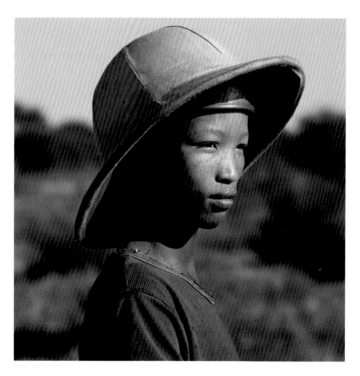

THIS PAGE: *San Bushman Boy, Botswana, 2009*
OPPOSITE PAGE: *San Bushman Elder, Botswana, 2009*

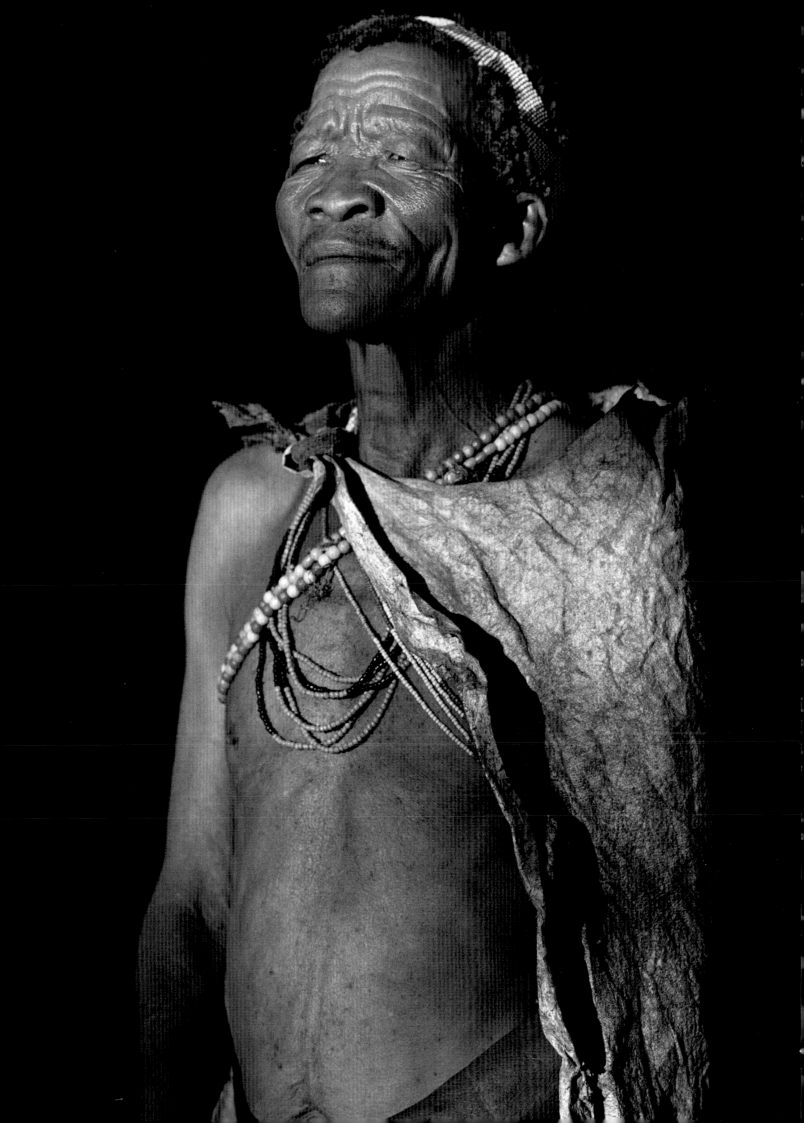

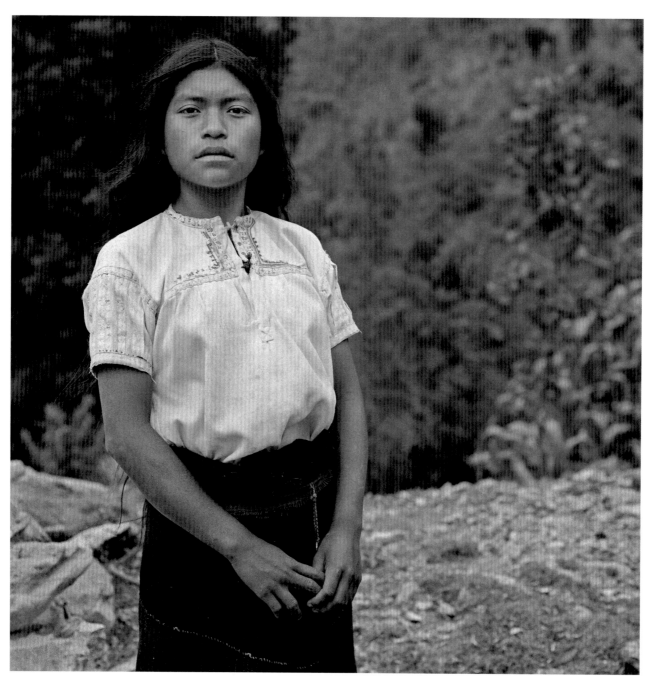

THIS PAGE: *Chamula Maya Girl, Chiapas, Mexico, 1987*; OPPOSITE PAGE: *Chamula Maya Boy, Chiapas, Mexico, 1987*

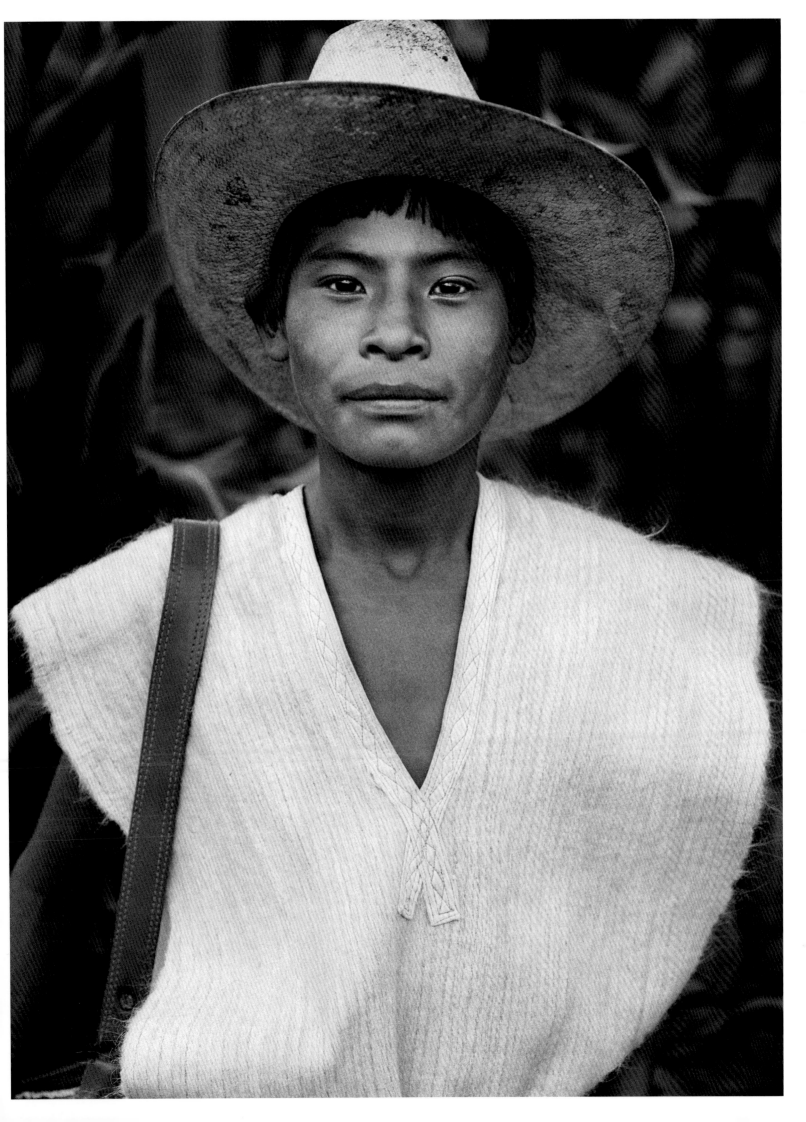

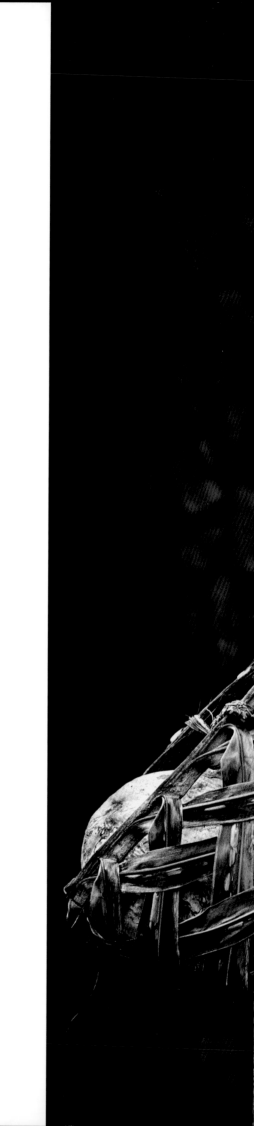

Laborer, Fiji, 2008

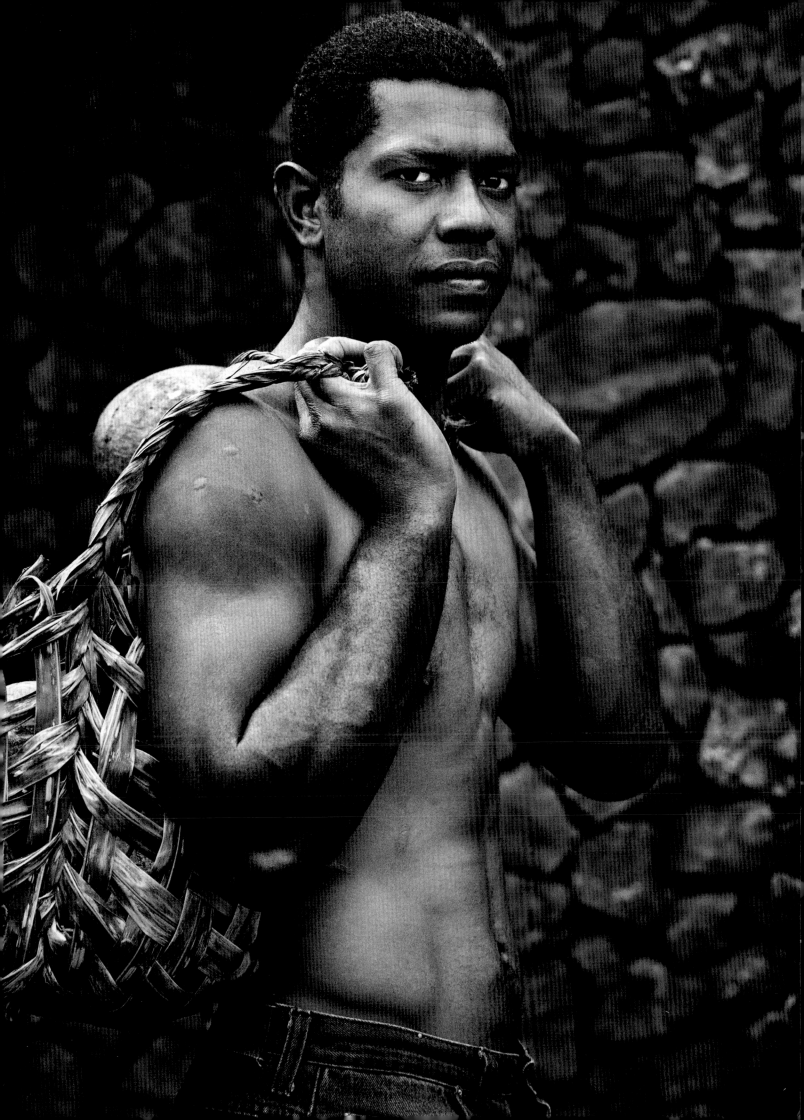

Himba Girl, Namibia, 2007

Himba Headman's Son, Namibia, 2007

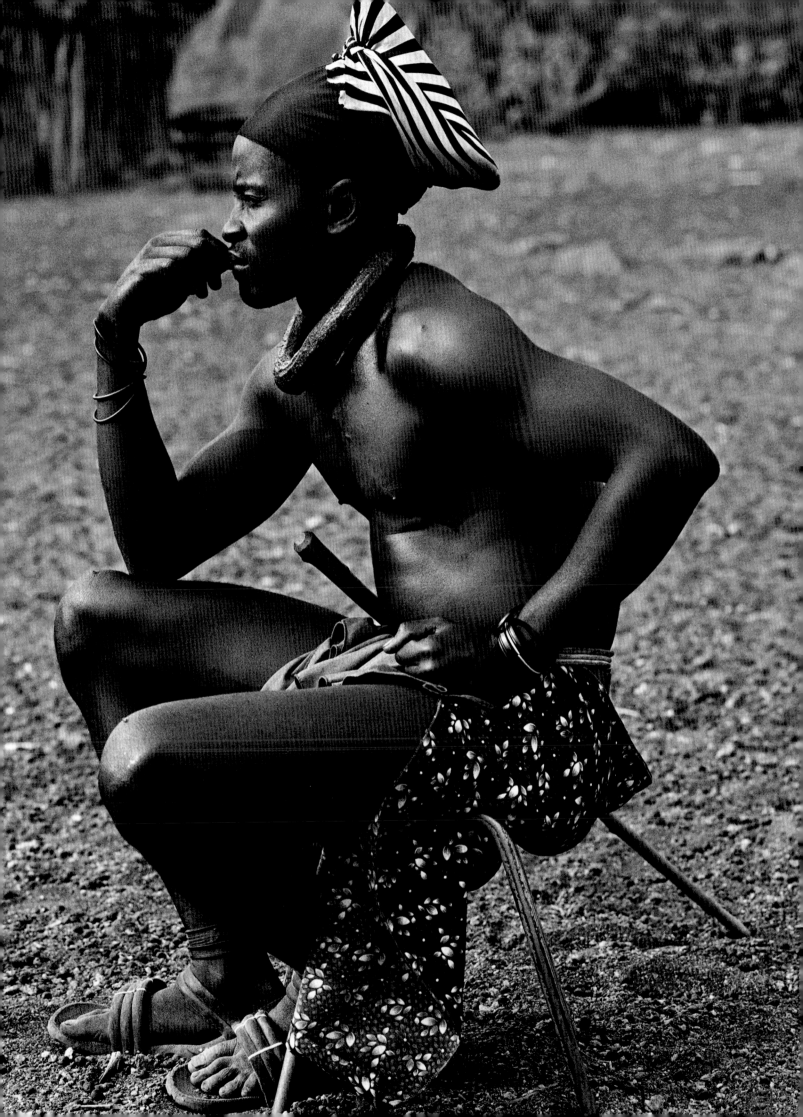

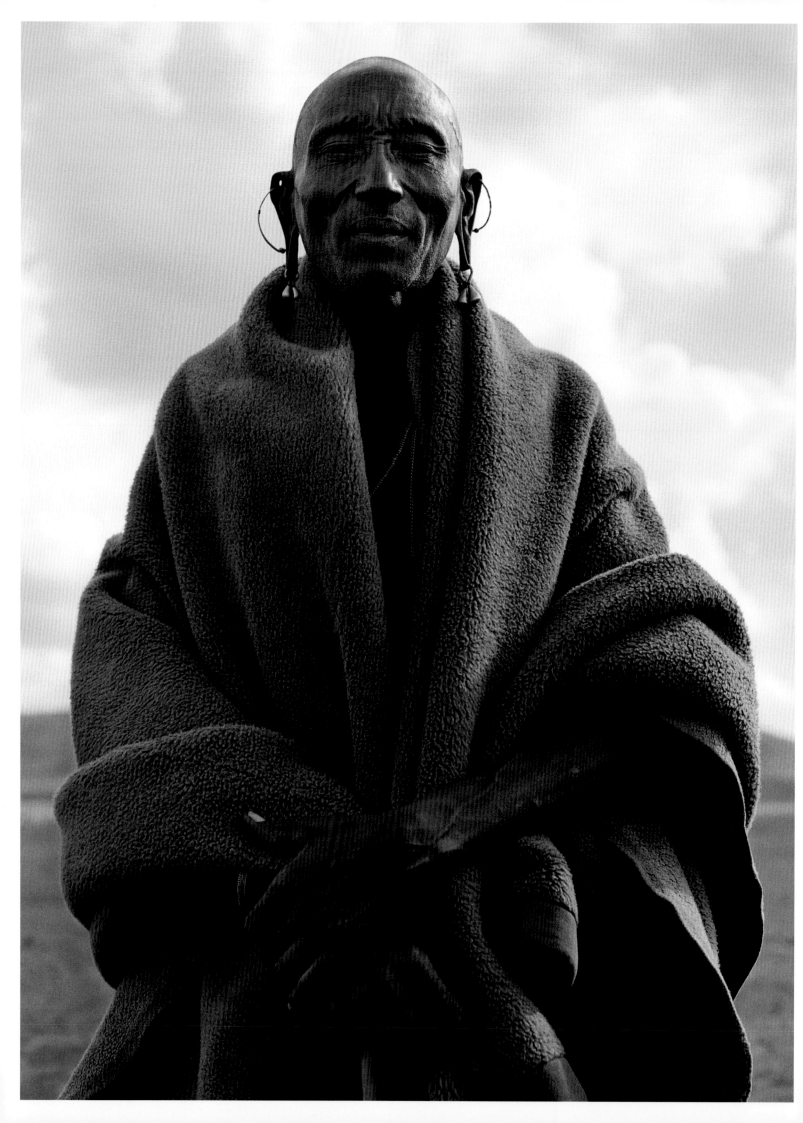

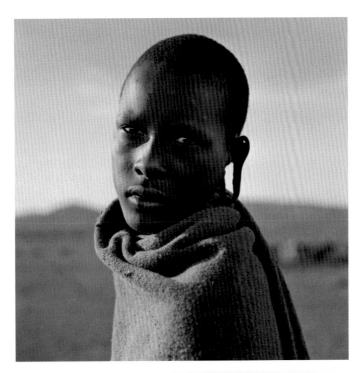

OPPOSITE PAGE: *Masai Chief, Kenya, 1985*; THIS PAGE: *Cow Herder, Kenya, 1985*

Keeper of the Hopi Prophecies, Gathering of Spiritual Leaders,
England, 1987

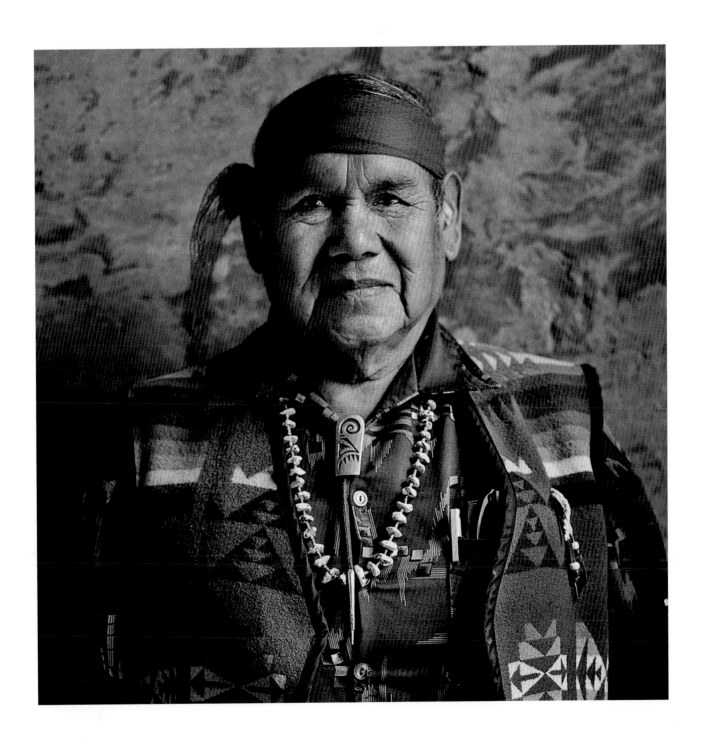

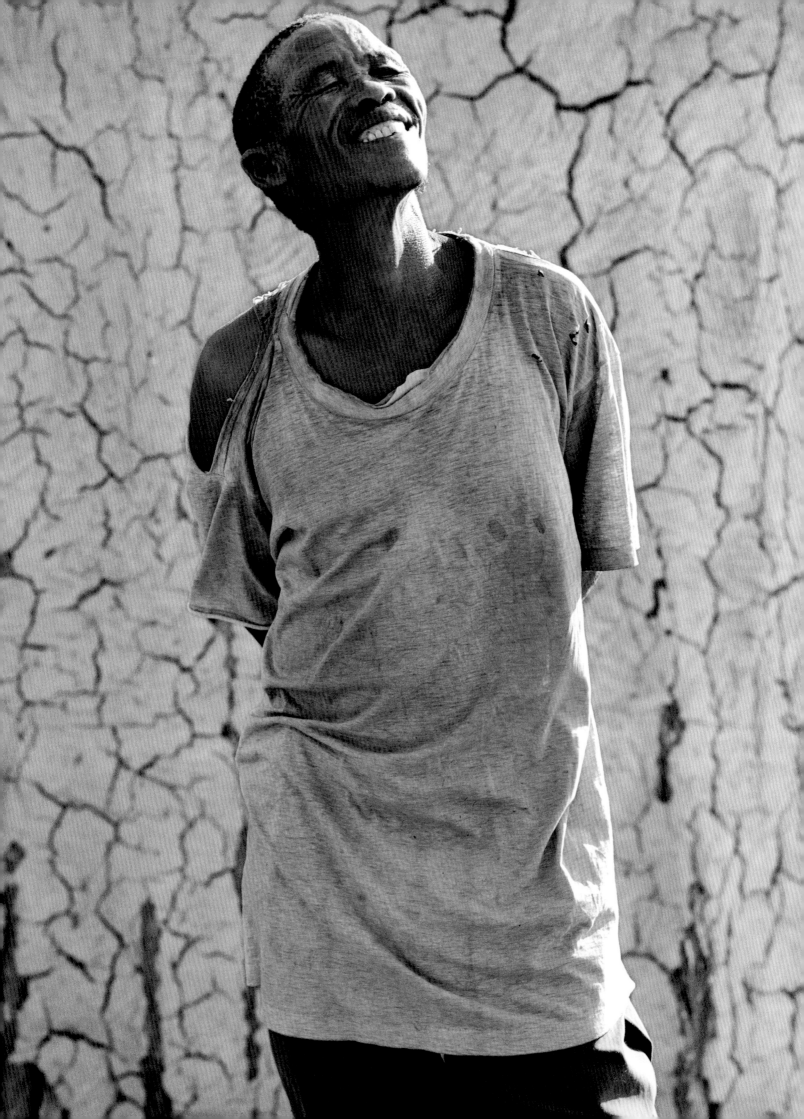

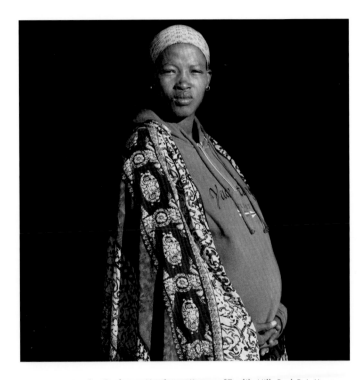

OPPOSITE PAGE: *San Bushman Headman, Keeper of Tsodilo Hills Rock Paintings, Botswana, 2009;* THIS PAGE: *San Bushman Teenage Girl, Botswana, 2009*

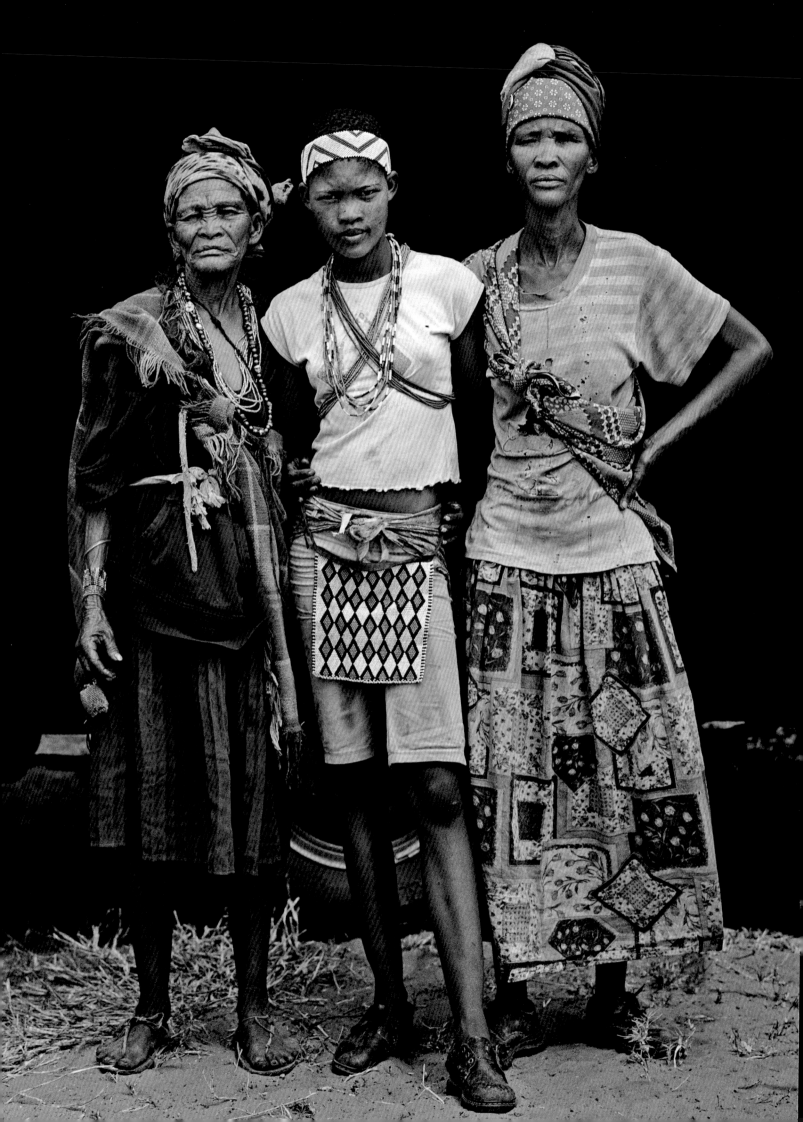

San Bushmen Grandmother, Granddaughter,
and Daughter, Botswana, 2009

Dancer, Oaxaca, Mexico, 2004

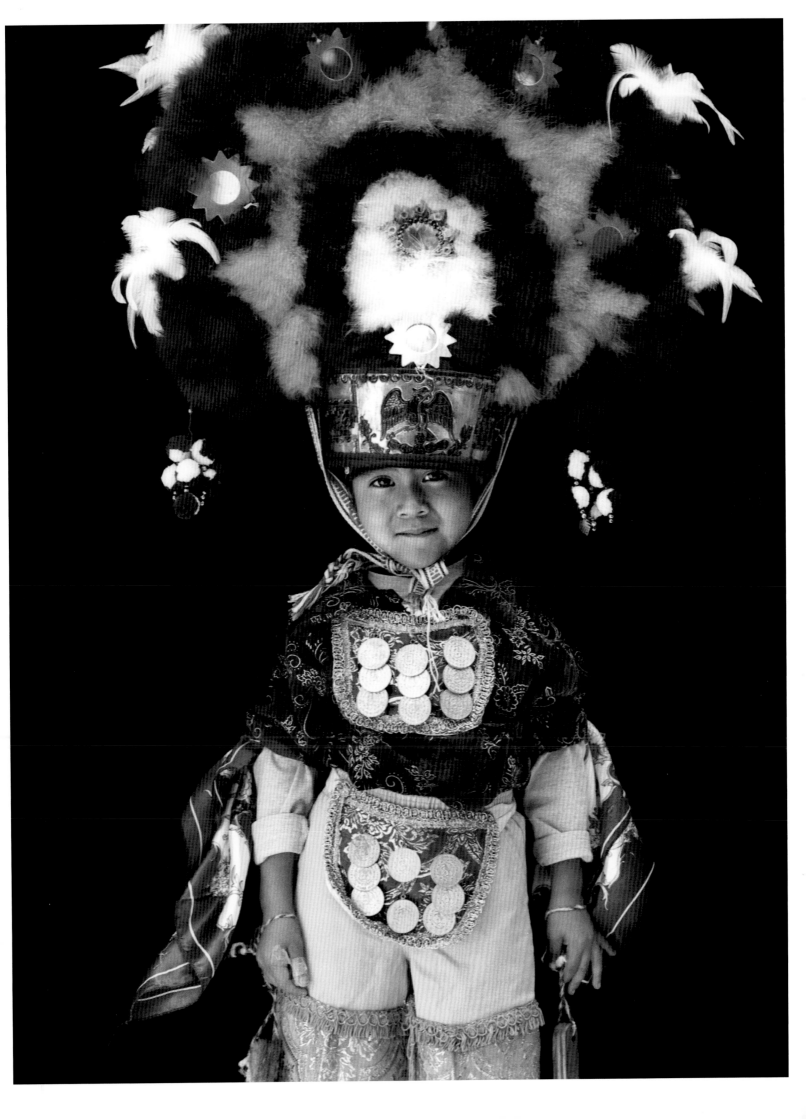

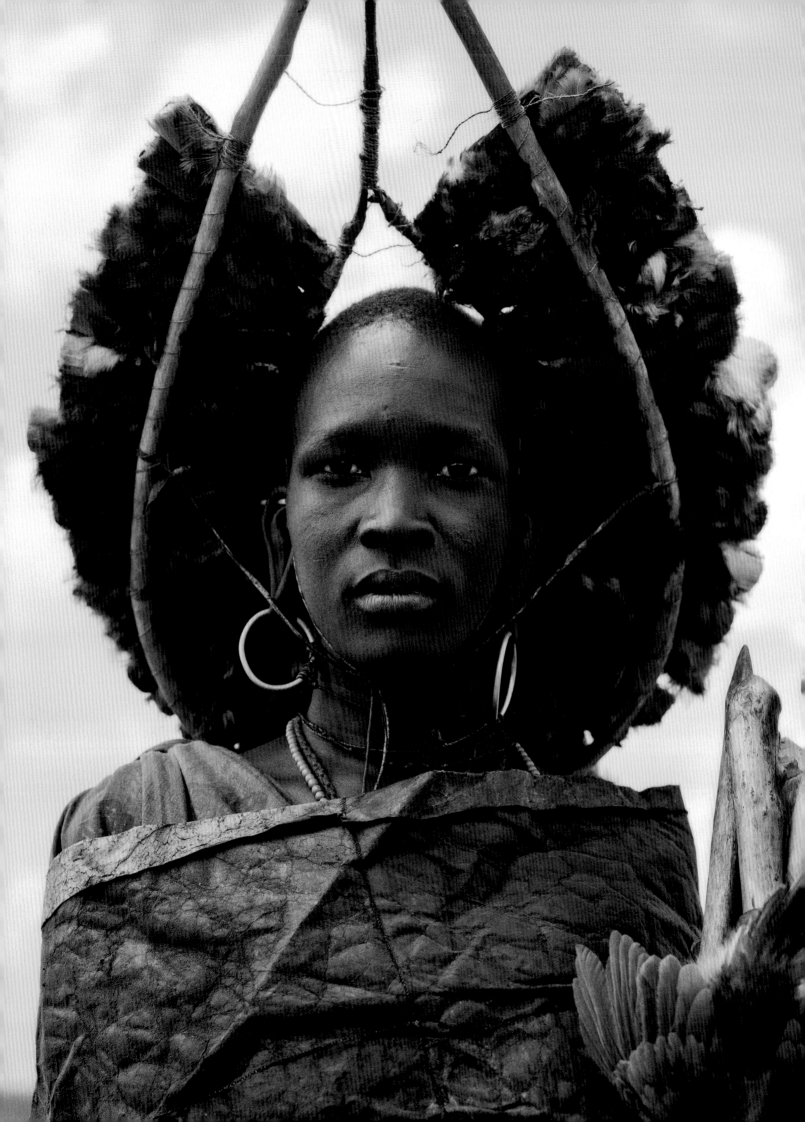

Masai Warrior Initiate, Kenya, 1985

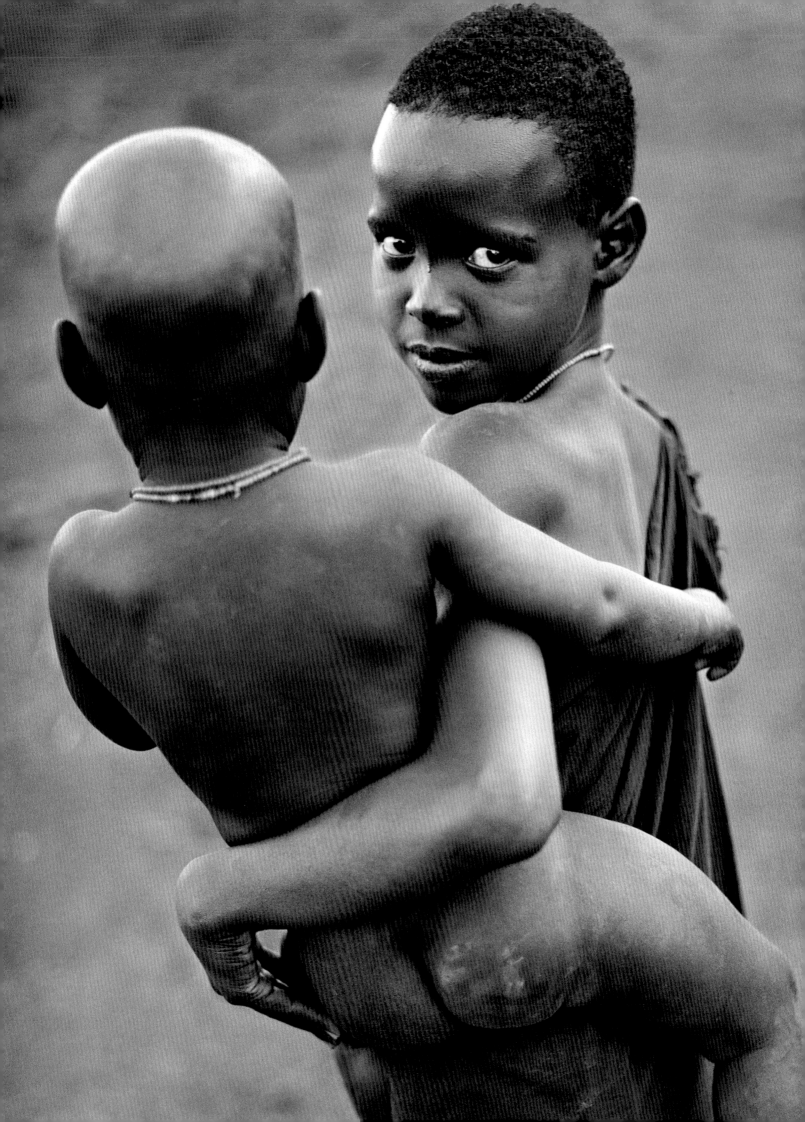

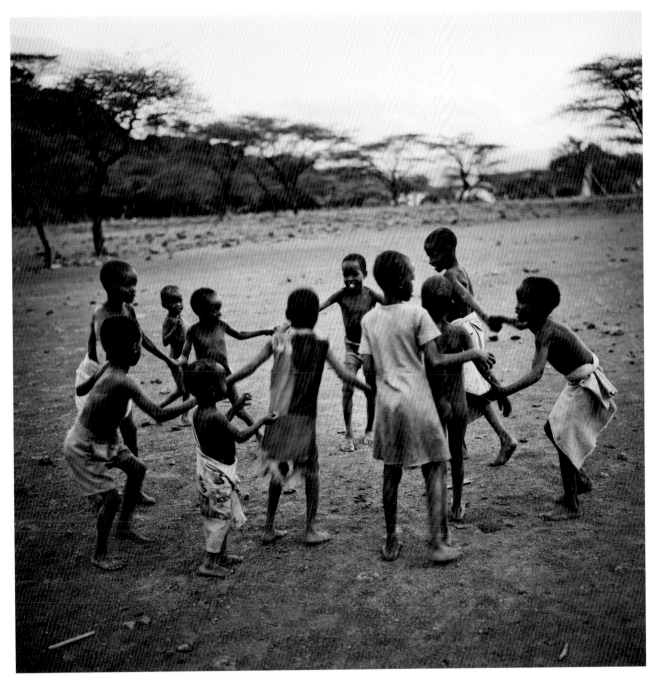

OPPOSITE PAGE: *Njemps Sister and Brother, Kenya, 1985*
THIS PAGE: *Njemps Children, Kenya, 1985*

Masai Blind Man, Kenya, 1985

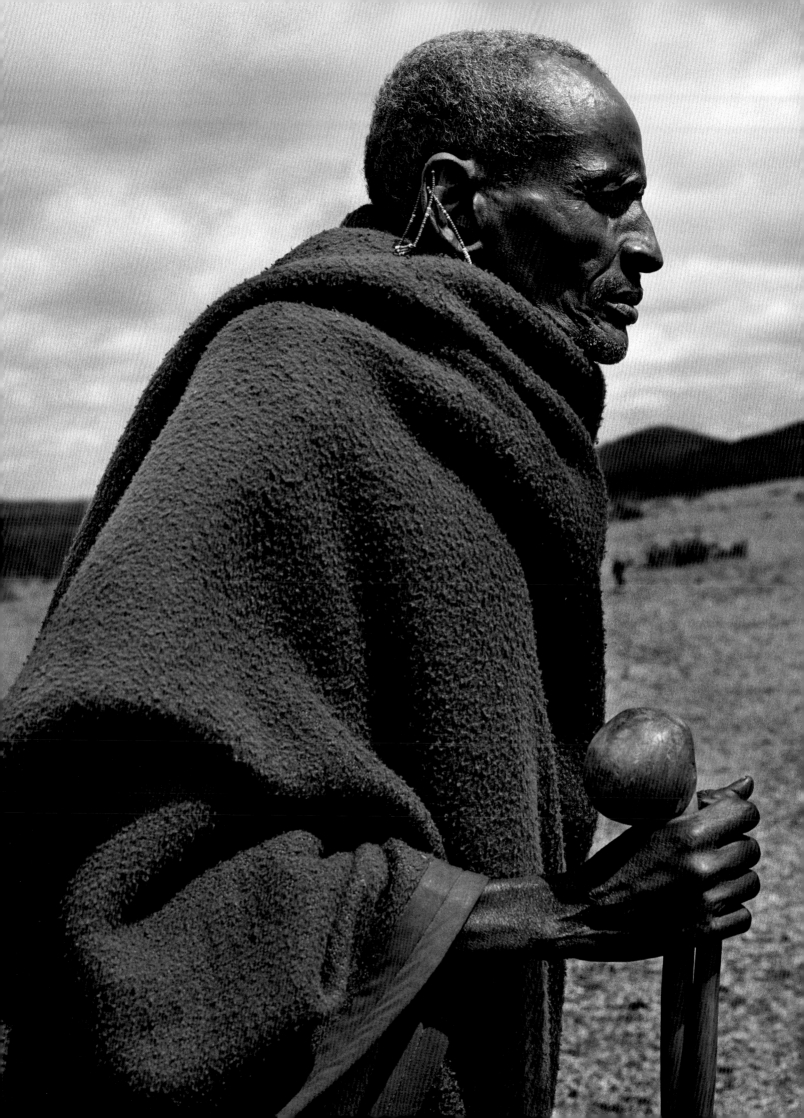

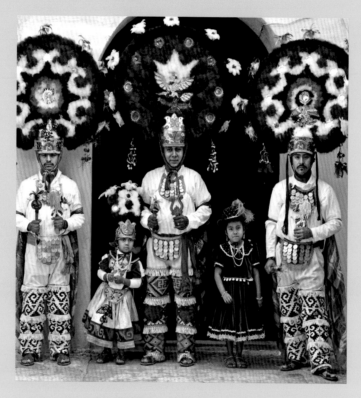

THIS PAGE: *Dancers, Oaxaca, Mexico, 2004*
OPPOSITE PAGE: *Elder Woman, Oaxaca, Mexico, 2004*

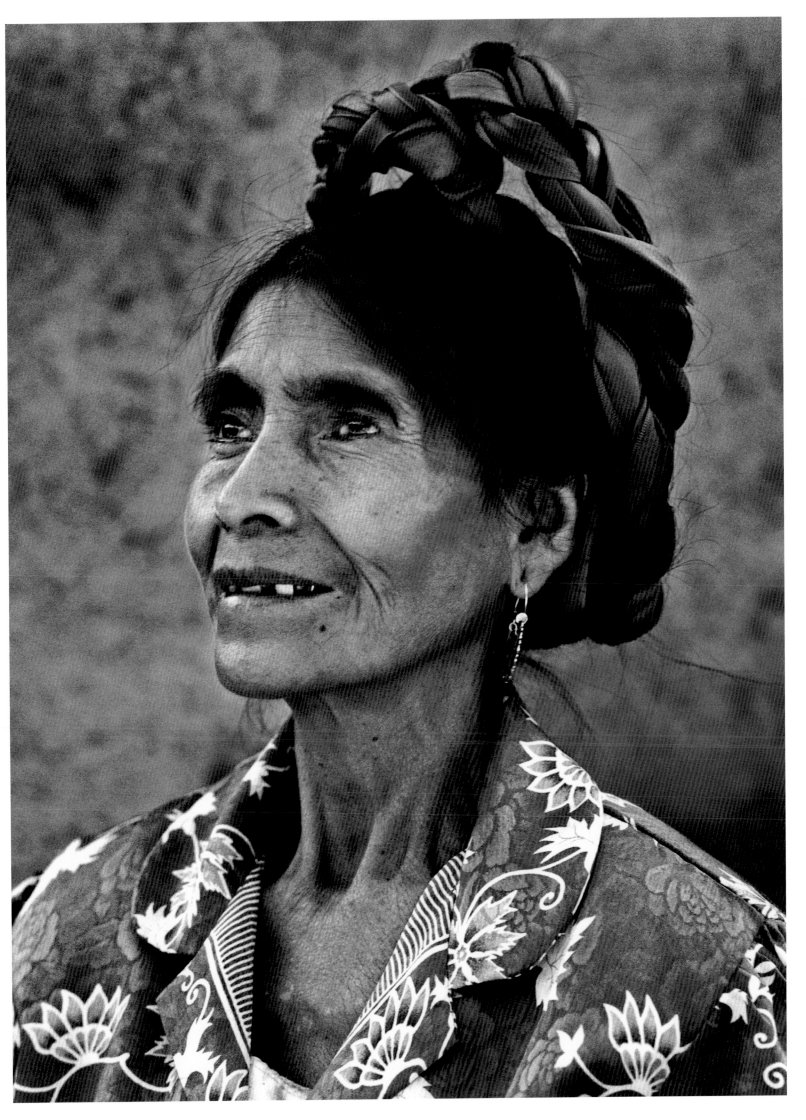

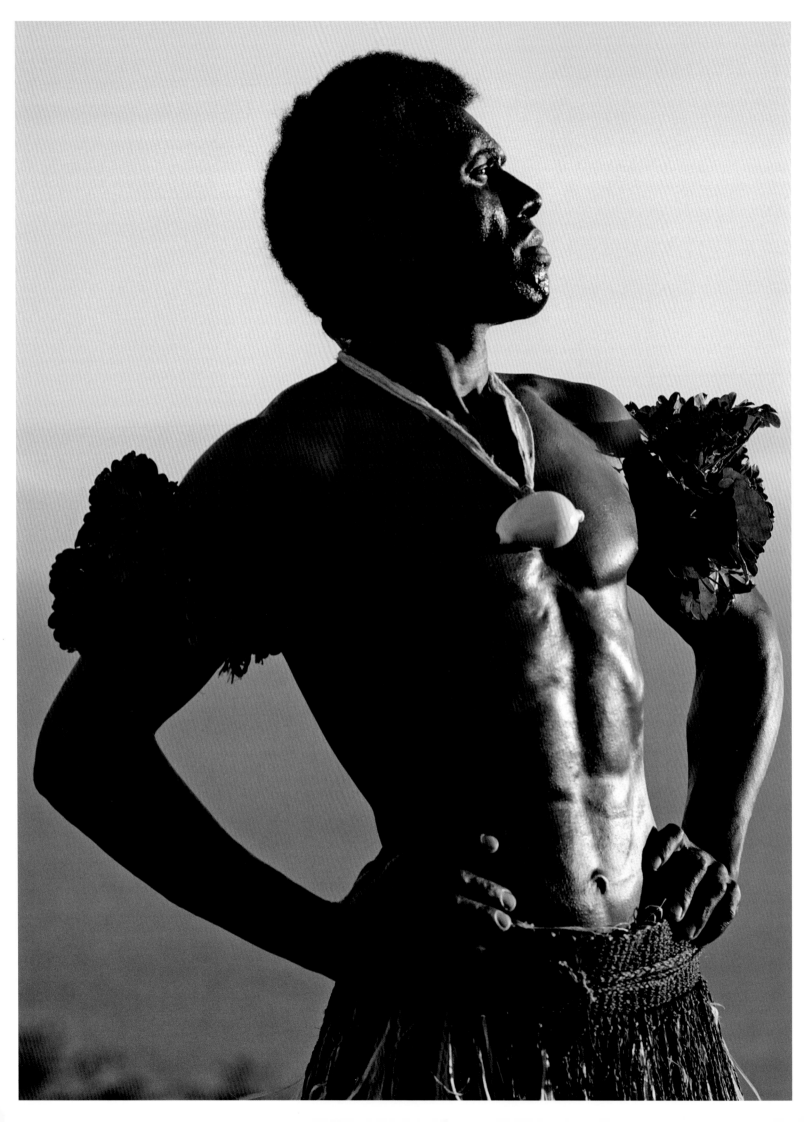

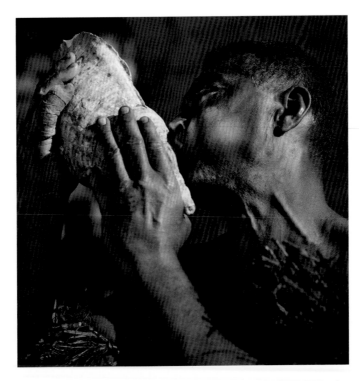

OPPOSITE PAGE: *Chief's Dancer, Fiji, 2008*; THIS PAGE: *Iraq War Veteran, Fiji, 2008*

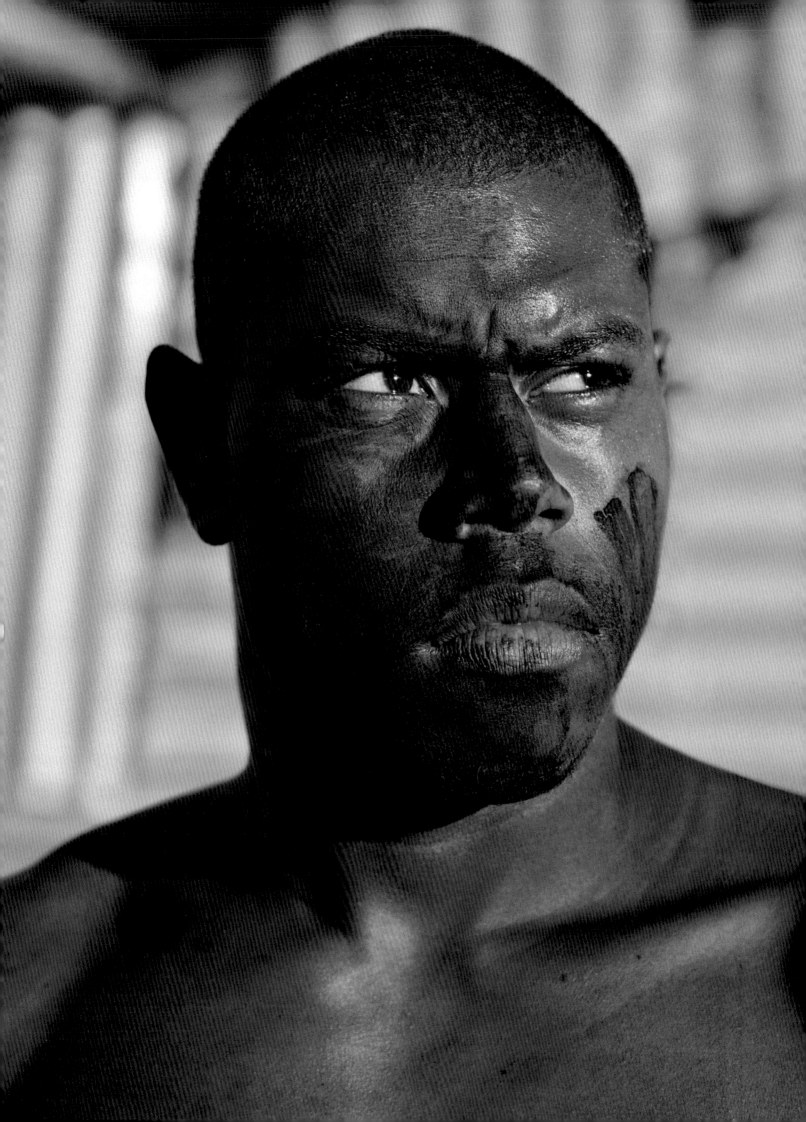

Chief's Warrior, Fiji, 2008

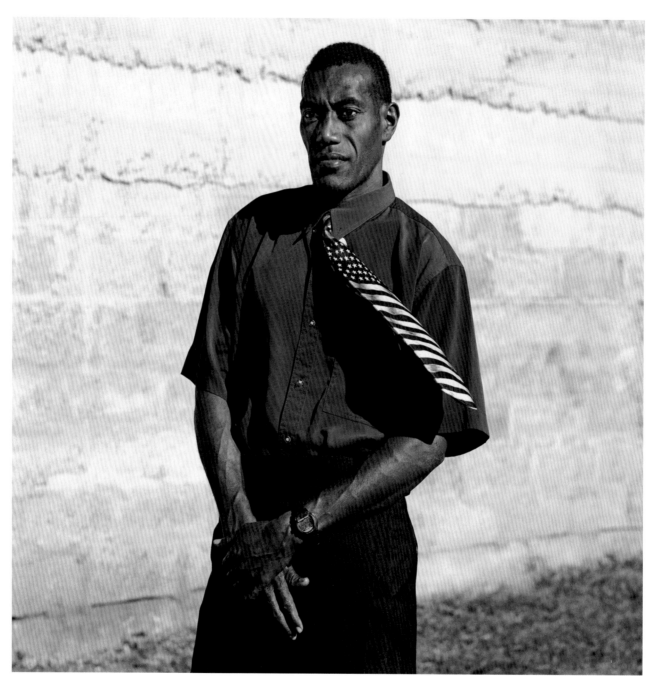

THIS PAGE: *Iraq War Veteran, Fiji, 2008*; OPPOSITE PAGE: *Chief's Steward, Fiji, 2008*

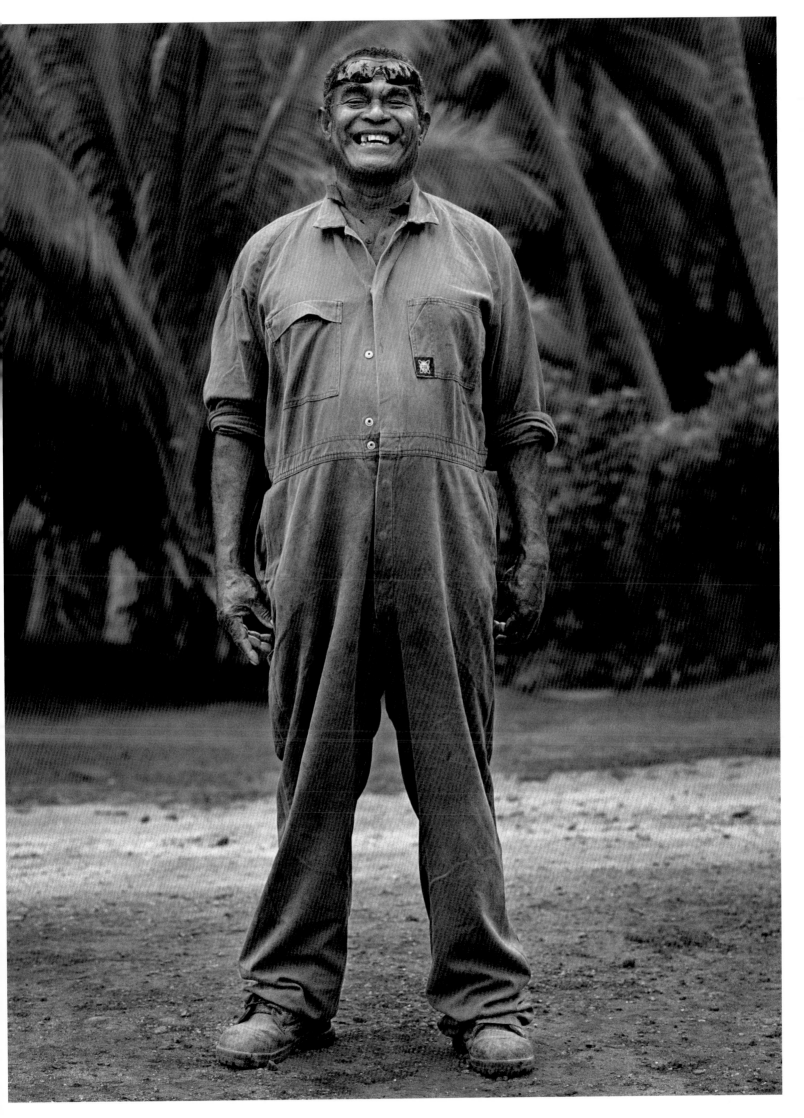

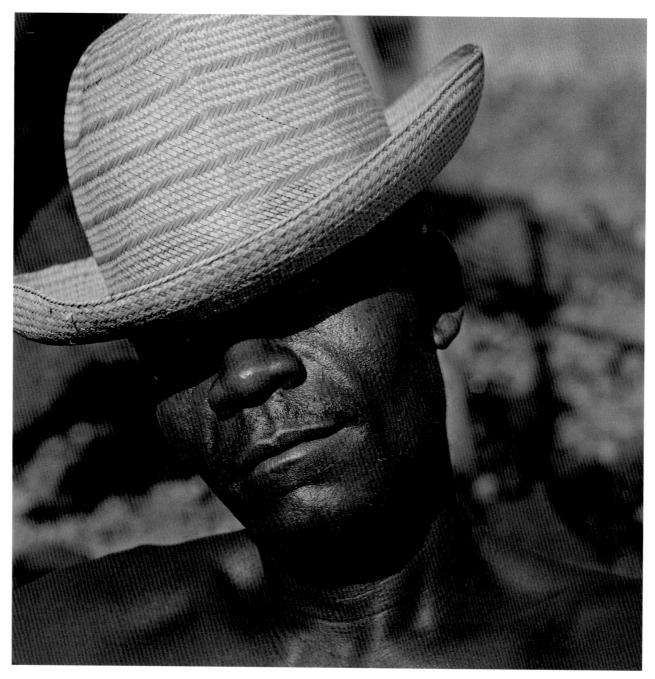

Laborer, Haiti, 1983

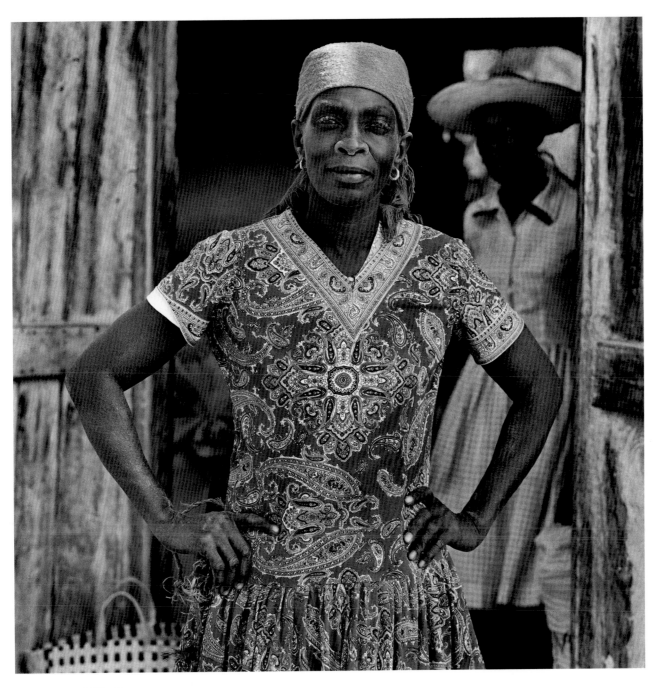

Granary Worker, Haiti, 1983

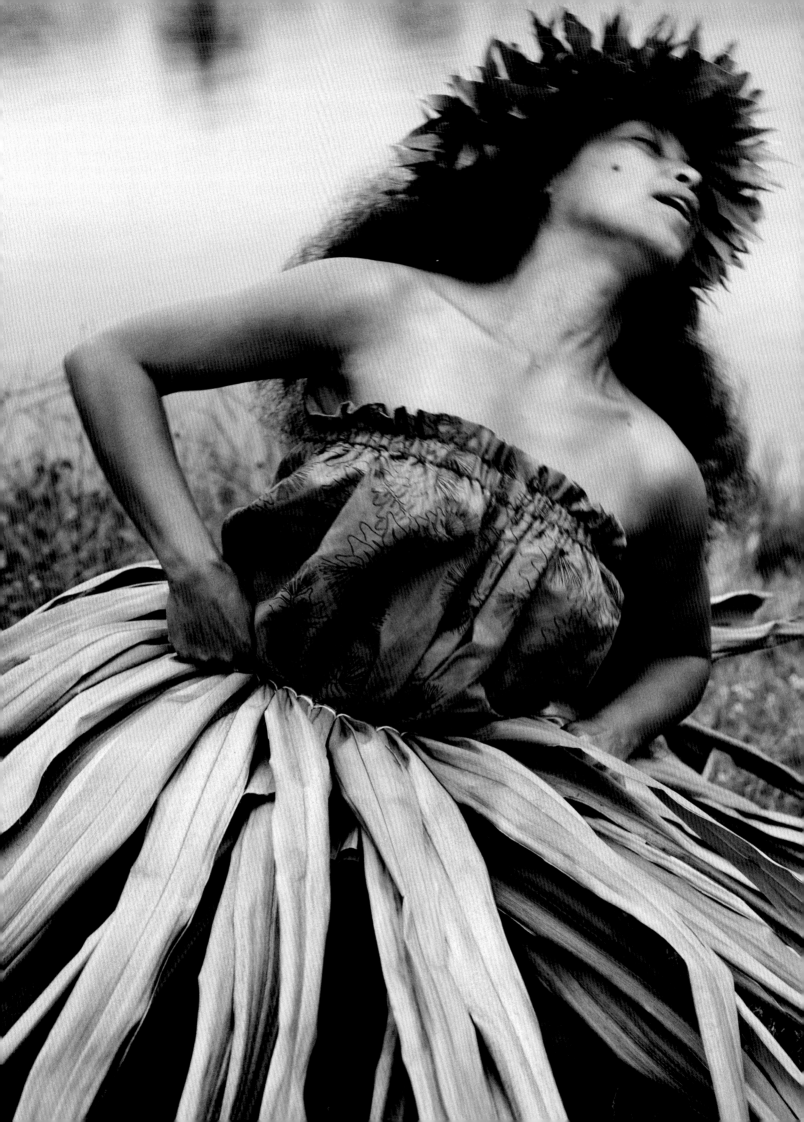

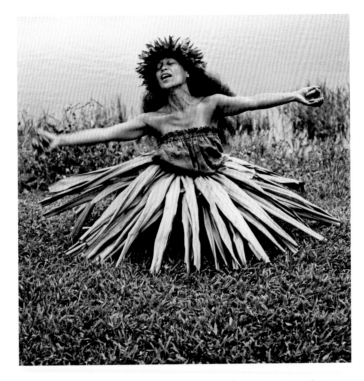

OPPOSITE PAGE: *Chanter, Hawaii, 1996*; THIS PAGE: *Chanter, Hawaii, 1996*

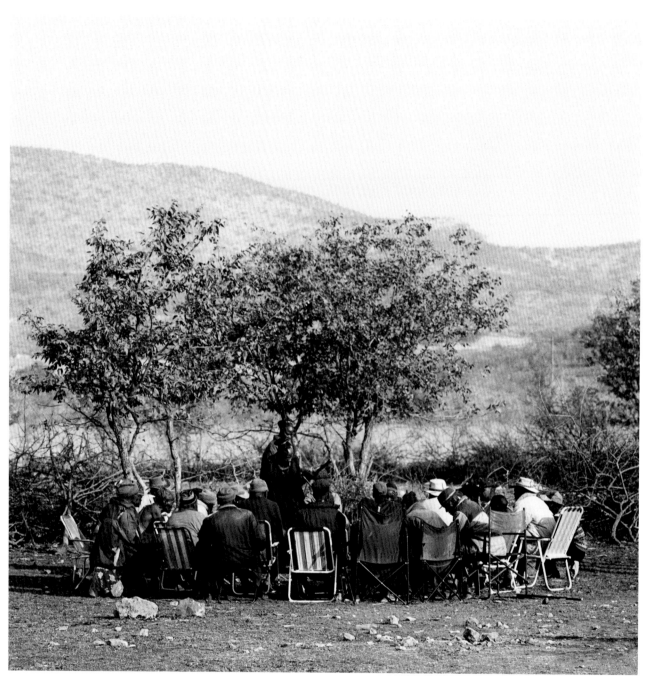

Herero and Himba Funeral Circle, Namibia, 2007

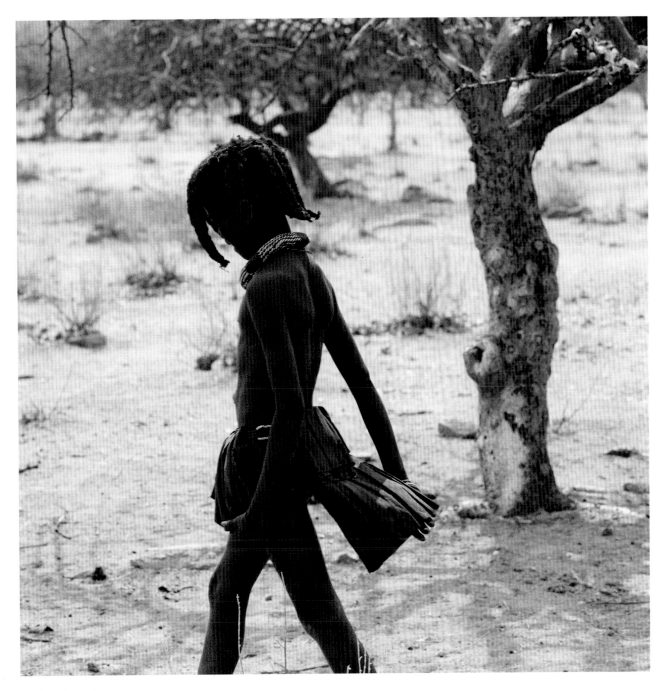

Himba Girl, Namibia, 2007

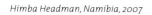

Himba Headman, Namibia, 2007

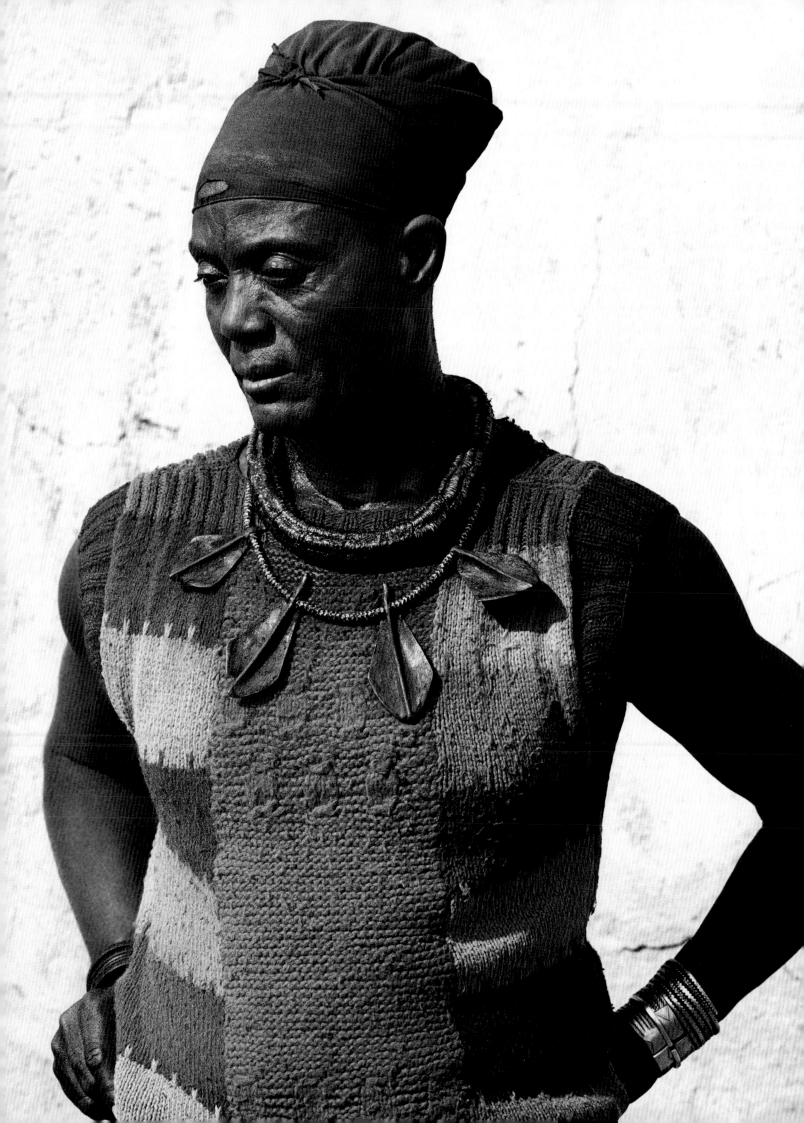

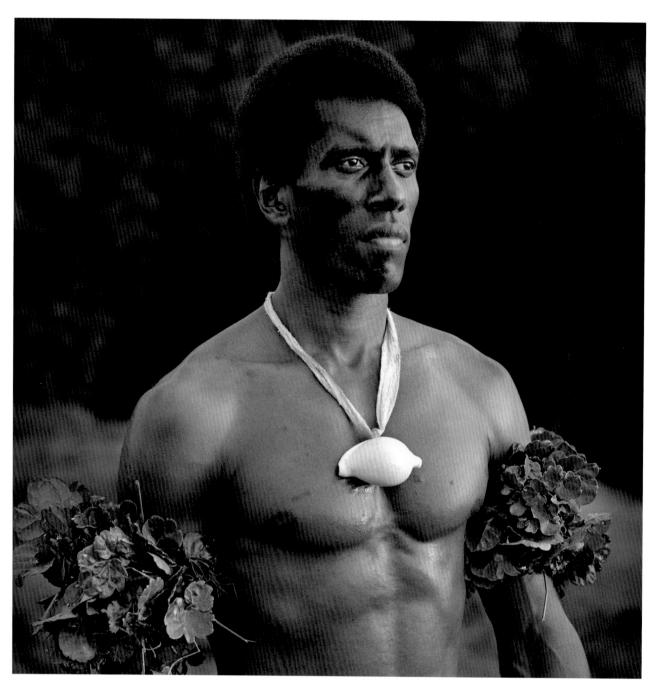

THIS PAGE: *Chief's Dancer, Fiji, 2008*; OPPOSITE PAGE: *Laborer, Fiji, 2008*

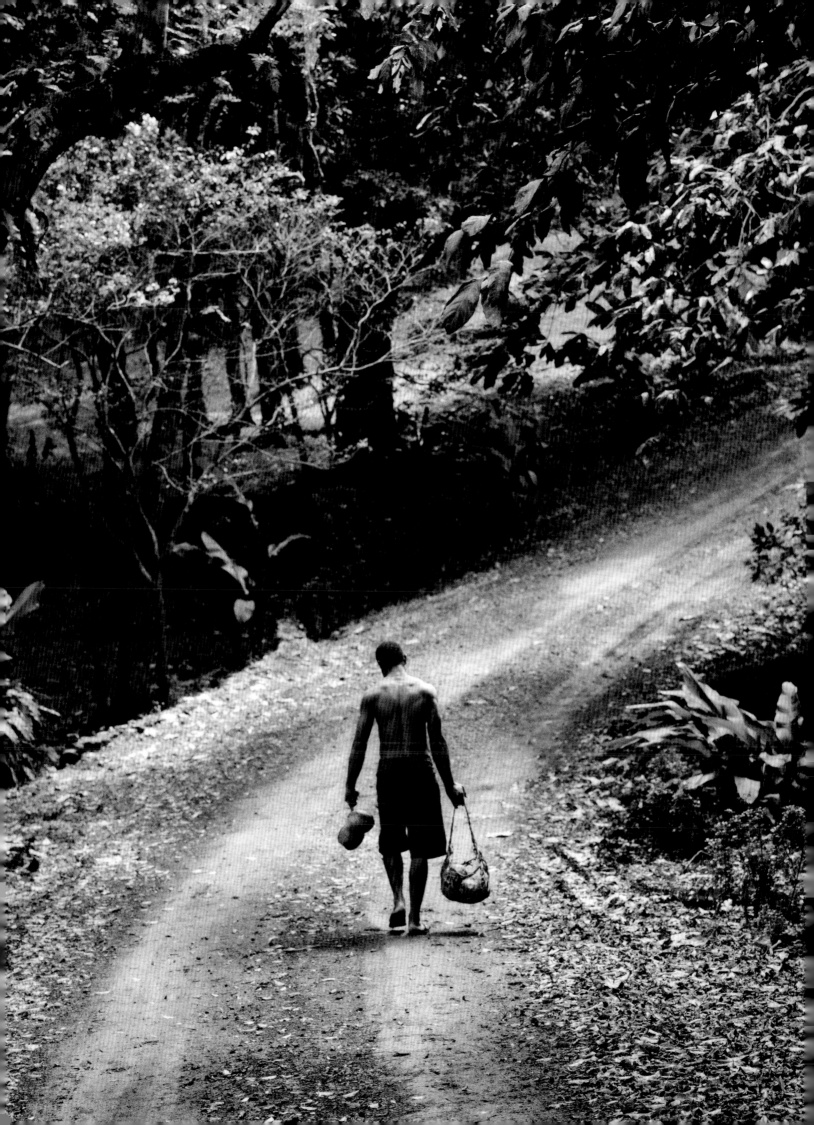

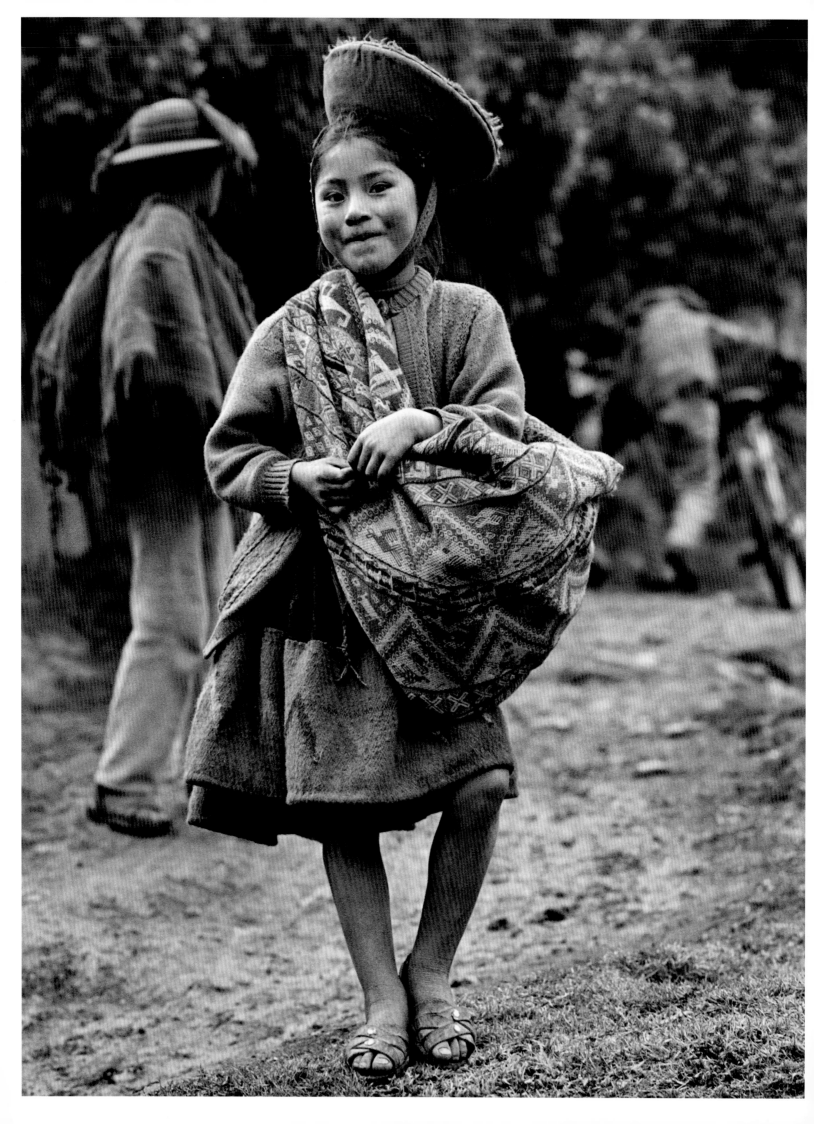

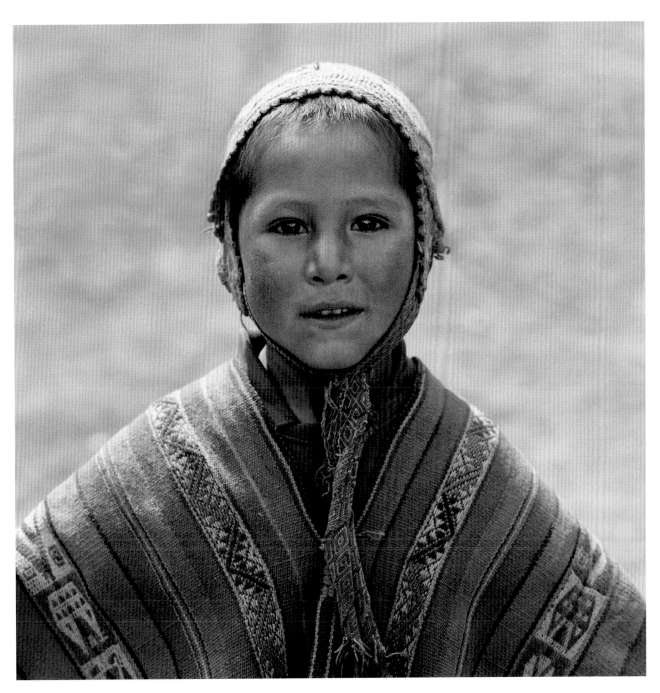

OPPOSITE PAGE: *Quechua Girl, Peru, 2006;* THIS PAGE: *Quechua Boy, Peru, 2006*

Goba Man, Zambia, 2007

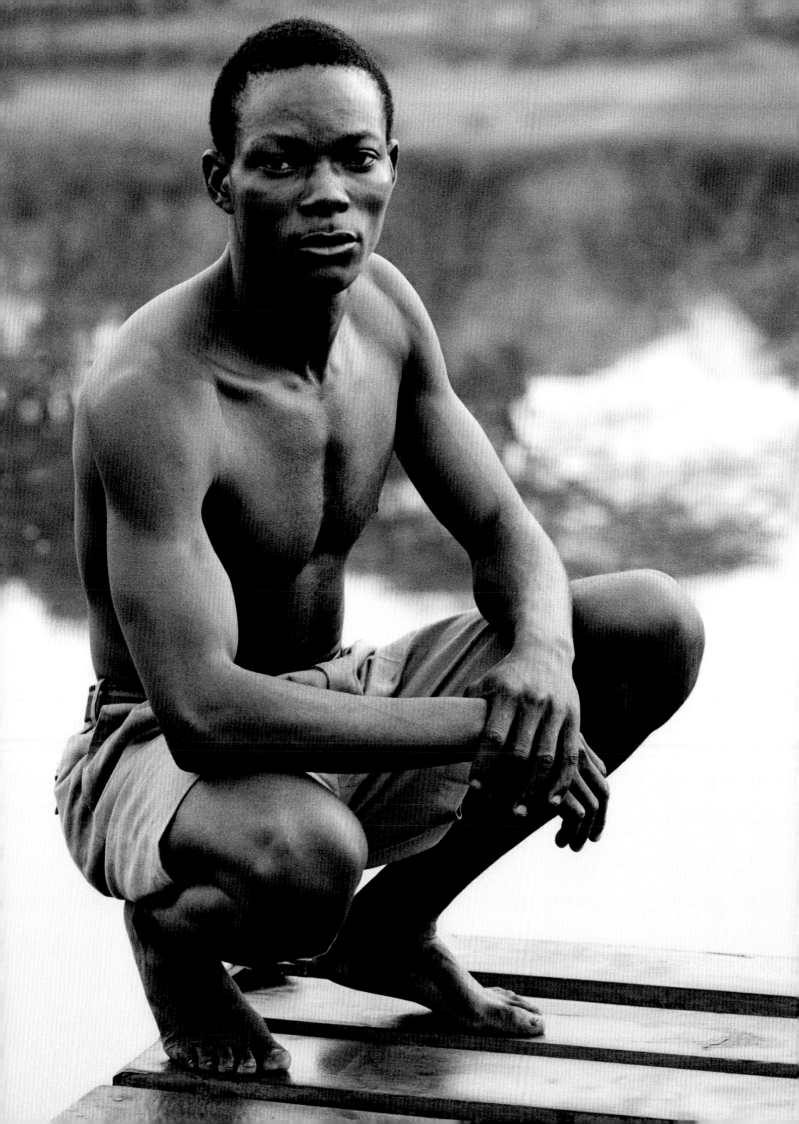

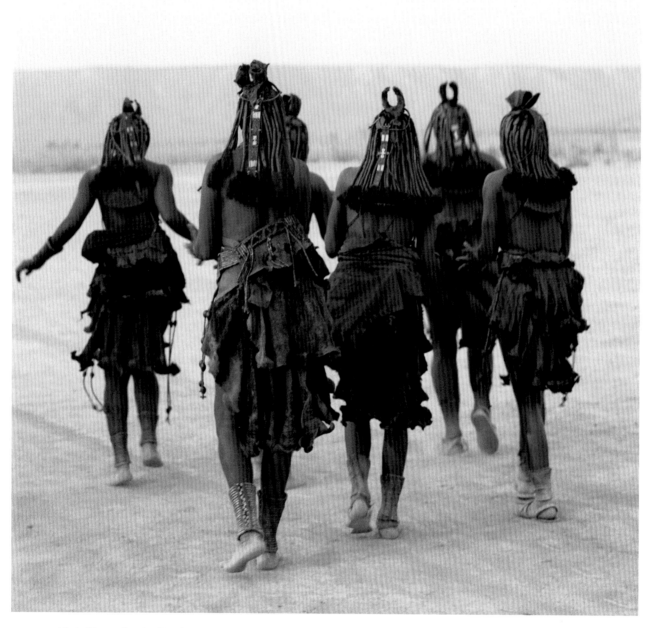

THIS PAGE: *Himba Women Dancing, Namibia, 2007*; OPPOSITE PAGE: *Herero Woman, Namibia, 2007*

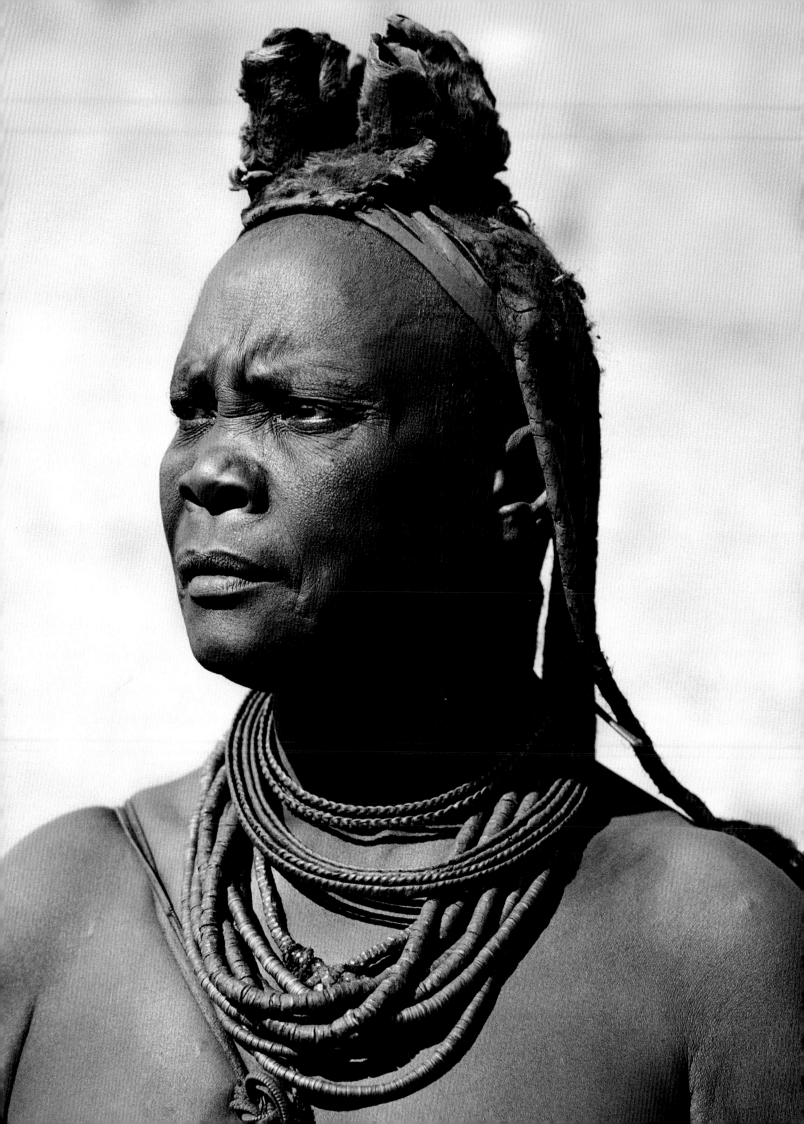

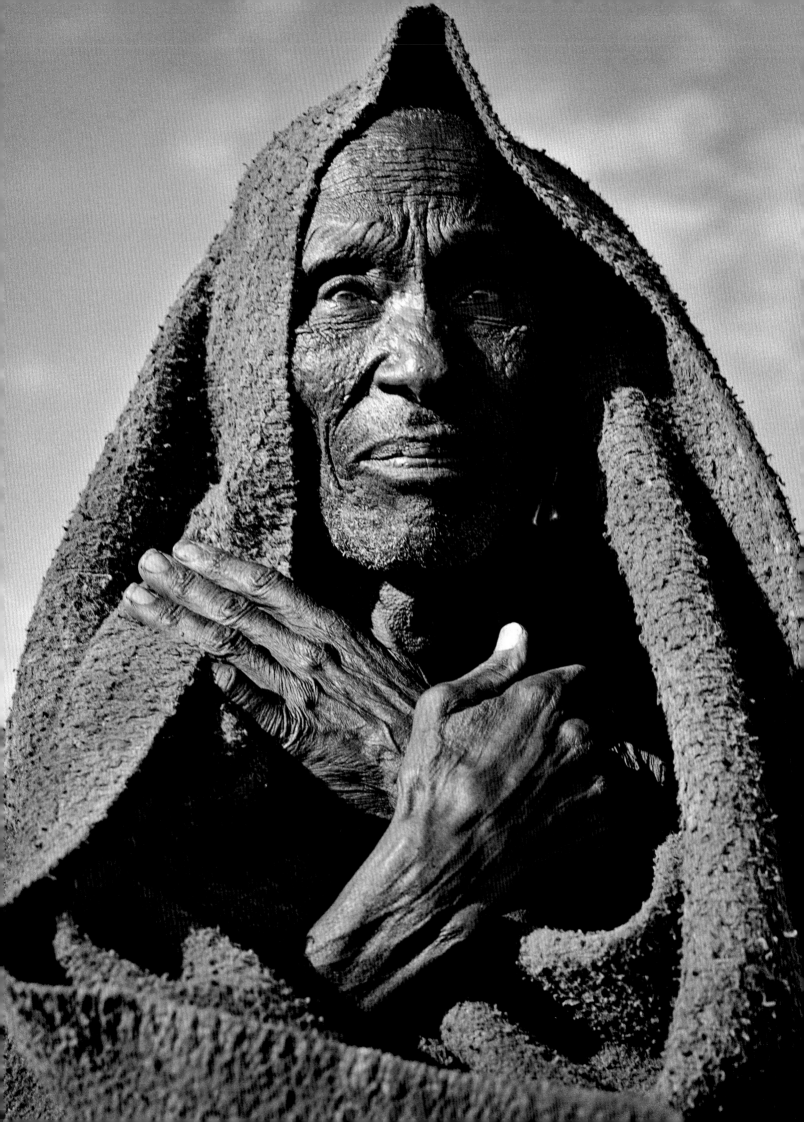

Masai Elder, Kenya, 1985

| DANA GLUCKSTEIN |

AFTERWORD

ONE OF MY TEACHERS, the Vietnamese Buddhist monk, Thich Nhat Hanh, once said to me, "If you don't know where you come from, how can you know where you are going?" The Indigenous Peoples I have spent my life photographing would agree. The tree cannot grow severed from its root.

I grew up in the Jewish "tribe," steeped in knowledge of the Holocaust. At our Passover table, I listened to those who recounted their own journey to freedom from the concentration camps. I was fortunate to grow up knowing all of my great grandparents. As a child, I remember my Bubbie Goldie sitting on my bed teaching me the evening prayers as I drifted off to sleep. These experiences of my heritage engendered a deep affinity for other cultures. In my early twenties, this calling took me to Haiti, then from continent to continent tracking the "ancient ones."

The Torah demands, "Justice, justice, pursue." I set out on my own pursuit of justice with a true soul mate, a trusted 1981 Hasselblad camera. Its slow, deliberate, weighty design and high-resolution square negative made me feel as if I could render the eternal in a photograph. For 30 years this camera has never failed me. I still wait reverently for the film to develop and to transport me into the mystical realm of images. The ability to capture time standing still, to witness the eternity that resides in a moment, is what I strive to achieve in a portrait session and the resulting images. Paradoxically, in that present moment caught on film, past and future moments merge. The act of creating an image becomes a ritual, a holy act that also allows the viewer to transcend time.

Over the decades, I have photographed Indigenous Peoples fighting for their lands, their traditions, their languages, and their very lives against corporate, governmental, and missionary interests and the encroachment of capitalism. Years ago, I met a beautiful man in a dusty roadside market in Kenya. With tribal markings on his forehead and a torn western t-shirt, he was caught between his traditional village and the modern capitol of Nairobi. He asked me to take his portrait. I called this image "Tribal Man in Transition" a thematic precursor to my current photographs.

In Zambia, impoverished boys from the Goba tribe, knowing that nothing remained of their authentic ceremonial adorn-

ments, made cardboard masks for their portrait. In Namibia, Ovazemba girls posed, one with a plastic toy cell phone dangling from a necklace and the other with a bra and no shirt—a collision of traditional, modern, and missionary cultures. I photographed a traditional Fijian warrior who had just returned from fighting a distant war in Iraq. The images from Bhutan depict the contradictions facing this ancient and mystical Himalayan culture whose admirable gross national product is measured in moments of happiness rather than the acquisition of material things. An onslaught of Bollywood and Hollywood images since television's introduction in 2000, however, threaten traditional values. At a religious festival, a school boy dressed in his traditional gho crouches with his toy rifle.

Recently, I photographed a San Bushman elder in Botswana, keeper of the legendary rock paintings at Tsodilo Hills, a descendent of the world's most ancient, peaceful, hunter-gatherer culture. The elder can no longer provide for his people because the government now requires him to purchase a "hunting license" he cannot afford. He asked, "How can we pass on our traditional dances and songs if we cannot hunt, if we have no skins?" His people have been forcibly removed to squalid resettlement camps because their land sits atop lucrative diamond mines.

Amidst such degradation and dispossession, there are stories of hope. The images of the Hawaiian Chanter, depict the cultural renaissance of Native Hawaiians who seek to heal the centuries of cultural erosion and loss of identity that followed the theft of their kingdom. Now their children attend Hawaiian cultural immersion programs where they learn to speak their once forbidden Hawaiian language, to dance their traditional hula, and to feel proud of their heritage.

It is my sincere wish that *DIGNITY* will serve as a critical call to action in support of all Indigenous Peoples. The "ancient ones" tell us where we have come from and where we must go as a world community. Humanity's survival depends on how carefully we listen.

With deep respect,
DANA GLUCKSTEIN

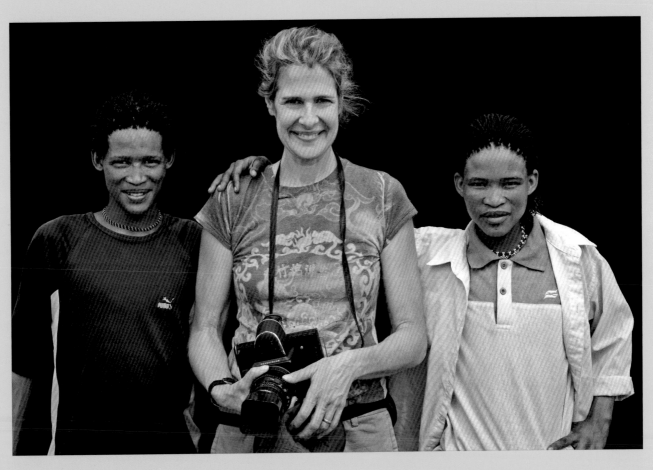

Dana Gluckstein with Komtsae Damo and Xixao Kxao, Botswana, 2009;
PHOTOGRAPH BY TAI POWER SEEFF

Qero Pakko Healer, Peru, 2006

| AMNESTY INTERNATIONAL |

EPILOGUE

THE ADOPTION OF THE United Nations Declaration on the Rights of Indigenous Peoples on September 13, 2007, marked the culmination of three decades of visionary advocacy by indigenous leaders from around the world. The declaration, which articulates the rights of Indigenous Peoples with bracing clarity and purpose, is a beacon for the human rights movement. We are both allies and students of the indigenous leaders who saw the urgent need for international recognition of their people's rights and marched forward, step by step, until they reached their goal.

The world has much to learn from the backstory to this remarkable achievement. First and foremost, those who crafted the declaration succeeded in distilling a core set of universal concerns from a multiplicity of oppressions faced by each group. A close reading of the declaration reveals the engine that drove this monumental, complex undertaking: a deep understanding of the innate dignity of all people. That insight sustained indigenous identities and cultures through centuries of genocidal violence, political disenfranchisement, economic marginalization, and educational policies designed to obliterate entire languages, traditions, and cultures. That insight impelled indigenous leaders to reach consensus about the rights—political, civil, economic, social, and cultural—that must be accorded the 370 million Indigenous Peoples of the world. They pursued that collective vision with absolute conviction.

The indigenous leaders displayed extraordinary tenacity as they shaped the highest ideals of a multitude of societies into a single declaration of rights and then steered that declaration to passage through generations of U.N. leadership. This tenacity carried them past the setback of four states (Australia, Canada, New Zealand, the United States) voting against the declaration and 45 states either abstaining or declining to participate. And it continues to reap substantive rewards. In 2009, for example, Australia endorsed the declaration and issued a formal apology to the Aborigines; in April 2010 New Zealand also endorsed the declaration, and the U.S. ambassador to the United Nations announced that the United States would formally review its position. These positive developments are a testament to the power of sustained advocacy and a vital reminder of the perseverance required to bring about the shifts in consciousness for which we work day after day, year after year, decade after decade.

The Declaration on the Rights of Indigenous Peoples, like other U.N. declarations and covenants, does not eliminate oppression, but it does alter the balance of power. It cannot stop corporations from attempting to seize tribal lands to extract oil or minerals or precious gems, but it can lend the force of an emerging set of international legal norms to those who seek protection or redress. The declaration is, ultimately, a visionary statement; it is up to us to make it a living, breathing instrument of human rights.

Dana Gluckstein's portraits call upon us to do just that. Her glorious images reveal a deep collaboration between photographer and subject, as if they had made a pact to suspend time so that we, the viewers, could contemplate the full import of the declaration. Amnesty International is deeply honored to be part of a project that celebrates a human rights milestone by so beautifully conveying the dignity of individuals.

What we can learn from the indigenous leaders who labored so long to bring forth an international declaration is that when people have a sense of their own dignity, they are unstoppable. The leaders who guided this process are midwives of wisdom, compassion, and justice.

We have been, and remain, humbled by their example.

LARRY COX
EXECUTIVE DIRECTOR,
AMNESTY INTERNATIONAL USA

| ARTIST ACKNOWLEDGEMENTS |

DANA GLUCKSTEIN

Everyone carries with them at least one and probably many pieces to someone else's puzzle. Sometimes they know it. Sometimes they don't. And when you present your piece which is worthless to you, to another, whether you know it or not, whether they know it or not, you are a messenger from the most high.
RABBI LAWRENCE KUSHNER

TO THE MANY WHO HAVE ILLUMINED MY PATH, I express my deepest gratitude. To Archbishop Desmond Tutu for our memorable portrait session on the eve of the South African elections in 2009 and for your radiant Foreword; to Oren R. Lyons, Faithkeeper, my lifelong mentor, for your profound Introduction; to Amnesty International for championing the dignity of humanity with special thanks to Helen Garrett, Larry Cox, Craig Benjamin, Sara Wilbourne, Markus N. Beeko and Monika Luke; to powerHouse Books and Langen Müller - terra magica for believing in *DIGNITY*; to John Klotnia of Opto Design and Kira Csakany, for your exquisite graphic design; and to Barbara Cox of Photokunst, my agent, for connecting all of us; to the Urban Zen Foundation for hosting the *DIGNITY* launch at their elegant New York studio with special thanks to Donna Karan, Joanne Heyman, and Sonja Nuttal; and to Darnell D. Jackson and Steven Riga of MorganStanley SmithBarney for their passionate sponsorship of this event.

To the generous donors to Tribes in Transition, my nonprofit, a project of the Tides Center, who supported the San Bushmen and Bhutan photographic expeditions: Abigail Disney, Donna Karan, Pauline Andrews, Judy Carroll, Carina Courtright, Jodie Evans, Bill and Joan Feldman, Sharon and Herb Glaser, Terry Hamermesh, Barbara Kabot, Fred and Joan Nicholas, Toni and Jim Kaplan, Steve Polivka, Susan Saltz, Lynne Goldman Silbert, Rick Rosenthal and Nancy Stephens, and Margery Tabankin; to collectors Susan Grode, Lisa and Tim Kring, Ina Coleman and Alan Wilson, and the many others who have supported my work over the years.

To the extraordinary Amanresorts for sponsorship in Bhutan at their beautiful, contemplative Amankora lodges, thank you for making the last photographs for *DIGNITY* possible, with gratitude to John Reed, Ian Bell, Debbie Misajon, Torunn Tronsvang, Tshewang Norbu, Tshering Norbu, Navina Tapa, Anu Gurung, Nawang Gyeltshen, and Chimmi Tshering.

To my favorite art director, Miles Turpin, and the Hoffman/Lewis agency thank you for creating the advertising campaign for *DIGNITY*; to Robert Parker and Noah Herzog of Executive Producer for the gracious contribution of film editing.

To those devoted friends who contributed their professional expertise; Sharon Gelman, beloved advisor and Executive Director of Artists for a New South Africa; Tai Power Seeff for donating her time as a remarkable assistant in Botswana; to Althea Edwards, magnificent print maker; to Keith Williamson, printer extraordinaire, for many years shared happily in the darkroom bringing these images to life; to Sarah Strack, my cherished assistant; to lifelong friend and lawyer, Scott Schwimer, and Terry Carlson for donating their time; to editors Laurie Leff, Janet Wertman, Steve Mackall, and Rabbi Jonathan Omer-man; to A & I Photography Lab in Los Angeles; filmmakers Katie Hyde and Jack Lewars; to Cherri Briggs of Explore Africa, and Los Angeles gallery owners Alitash Kebede, Jan Baum, and CC H Pounder, and Barbara Ruetz of Galerie an der Pinakothek der Moderne of Munich, Germany.

To my first teachers at Stanford University who believed in me from the start, the late Leo Holub, and Robert Parker; to Martin Treu, who commissioned my first shoot for *San Francisco Magazine*; to my photographic mentors, Norman Seeff and the late Jo Anne Hertz; to the museum curators that recognized my vision, the late Robert Sobieszek, and Tim Wride, both formerly at the Los Angeles County Museum of Art, and to Karen Sinsheimer, at the Santa Barbara Museum of Art.

To my devoted husband Michael, who never lets me give up; to my precious daughter, Marena, my favorite photo assistant; to my talented musician son, Colin, who keeps me young; and to my adoring mother and father, Rochelle and Robert Gluckstein,

whose constant love has nourished me throughout my lifetime.

To the proud and beautiful subjects who stepped forward to share their character, thank you for knowing deep inside that this work mattered and would some-day make a difference in the lives of many. Thank you to all the keepers of the sacred traditions—the heal-ers and medicinal plant gatherers, the chanters and dancers, the art-ists and musicians, the weavers, the children, and the sacred sites where we collaborated. To the late Thomas Banyaca, revered Hopi Na-tive American spiritual leader; to Banduk Marika of Australia; to the

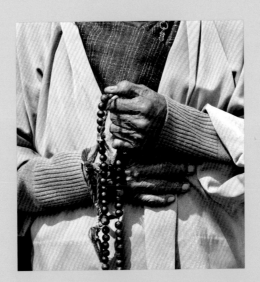

Elder Woman, Bhutan, 2010

late Chan' Kin Viejo, 100-year-old shaman of the Lacandon Forest, Mexico; to Don Benito, Qero Pakko healer of Peru; Malie Rea, Ha-lau o Kekuhi, Hawaii; Kara Henderson and friends, Cambell River Indian Band, Canada; to Pema Wangyaz, Thinley Norbu, Tshering Dorji, Nawang Dorji, Nawang Yanten, Yanglay Dema, Tashi Nawa-nd, Yeshi Tshomo, Sonam Tshomo, Hap Tshering, Gembo Dorji, Wangchuk Dorji, Phub Pem, Kencho Om, Thinley Lham, Dorji Om, Dechen Om, Gem Dorji, Lhab Tshering, Chimi Wangdi, Sangay Khandu, Pema Drugyal Dzal, and Phuntsho Drayang, Dancers of Peace and Prosperity Through the Melody of Music in the ruins of the seventh-century Drukgyel Dzong; to the children of Gang-tey, Paro and Bumthang, in the Paro Dzong and the grounds of the Wangdicholing Palace in Bumthang, Bhutan; to Xixae Xhao, Bee Kaahashe, Khaxha Damo, Kgao Xhau, Nxae Xwii, Xhwa Xhashe, Nxixao Xoma, Gwanxa Gomme, Kgao Qam, Chqo Damo, Nxoshe Xukae, Xashee Xukae, Mogotho Tshao, Komtsae Damo, Xixao Kxao, Xushee Kgao, Kgamxo TIllao, Bau TIllao, Nxiquao

Xwill, Xhao Xoma, Xontae Xhao, Oza Xhao, Oza Boo, Nxianque Komstsa, and Nxao Xhao of Xai Xai and Tso-dilo Hills, Botswana; to Sitiveni De-lai, Vilikesa Tokoni, Taniela Kidimoce, Solomone Tabuaqoro, Solomone Tikoitotogo, Joeli Vuki, Atueta Savou, Eleanor Buadromo Muainacake Ful-aga Lau, Maria Cagicaucau, Mamasa Vuetinatotoka, and Kemueli Kila of Levuka and Wakaya, Fiji; to Michael Chilekoni, Elies, and Morfat Katiyo of Zambia; to Rodney Katuuja, Tjituaa, Vezemuna, Pane Houpene, Tjistua, Mbunguha Hembinola, Mehomaui Tjiramba, Vemutupisa, Mauetam-buijani Tjiuinda, Hambera Mu-hanrua, Kazahingua, Kouijendjezo Matundu, Ratouahimba Muhendje, Wauricirua, Watijaro Mb-inge, Muapaa, Waparisa, Mbateza, and Josef Matandu of Kaoko-land, Namibia; to Francisco Ruiz, Florentino Martinez, Francisco Bazan, Horacio Mendoza, Andres Contreras, Celso Ruiz, Armando Contreras, Heriberto Vasquez, Hugolino Ruiz, Liliana Garcia, and Faviola Martinez, Grupo de la Danza de la Pluma in the Iglesia of Teotitlan Del Valle, Oaxaca, Mexico; to the children of Huilloq in the Sacred Valley of the Andes, and the children of Cuzco, Peru; to the dancers of the Academy of Indonesian Dance at the ancient temple ruins of Ubud, Bali; to the children and elders of Chiapas, Mexico; to the families of the Masai Mara of Samburuland and the Njemps of Lake Baringo, Kenya; and to the courageous peo-ple of Haiti who inspired me with their depth and beauty, gifting one of the earliest and most meaningful pieces to my puzzle.

In Gratitude,
DANA GLUCKSTEIN

UNITED NATIONS DECLARATION ON THE RIGHTS OF INDIGENOUS PEOPLES

Adopted by General Assembly Resolution 61/295 on 13 September 2007

THE GENERAL ASSEMBLY,

GUIDED by the purposes and principles of the Charter of the United Nations, and good faith in the fulfilment of the obligations assumed by States in accordance with the Charter,

AFFIRMING that Indigenous Peoples are equal to all other peoples, while recognizing the right of all peoples to be different, to consider themselves different, and to be respected as such,

AFFIRMING also that all peoples contribute to the diversity and richness of civilizations and cultures, which constitute the common heritage of humankind,

AFFIRMING further that all doctrines, policies, and practices based on or advocating superiority of peoples or individuals on the basis of national origin or racial, religious, ethnic, or cultural differences are racist, scientifically false, legally invalid, morally condemnable, and socially unjust,

REAFFIRMING that Indigenous Peoples, in the exercise of their rights, should be free from discrimination of any kind,

CONCERNED that Indigenous Peoples have suffered from historic injustices as a result of, inter alia, their colonization and dispossession of their lands, territories, and resources, thus preventing them from exercising, in particular, their right to development in accordance with their own needs and interests,

RECOGNIZING the urgent need to respect and promote the inherent rights of Indigenous Peoples which derive from their political, economic, and social structures and from their cultures, spiritual traditions, histories, and philosophies, especially their rights to their lands, territories, and resources,

RECOGNIZING also the urgent need to respect and promote the rights of Indigenous Peoples affirmed in treaties, agreements, and other constructive arrangements with States,

WELCOMING the fact that Indigenous Peoples are organizing themselves for political, economic, social, and cultural enhancement and in order to bring to an end all forms of discrimination and oppression wherever they occur,

CONVINCED that control by Indigenous Peoples over developments affecting them and their lands, territories, and resources will enable them to maintain and strengthen their institutions, cultures, and traditions, and to promote their development in accordance with their aspirations and needs,

RECOGNIZING that respect for indigenous knowledge, cultures, and traditional practices contributes to sustainable and equitable development and proper management of the environment,

EMPHASIZING the contribution of the demilitarization of the lands and territories of Indigenous Peoples to peace, economic and social progress and development, understanding, and friendly relations among nations and peoples of the world,

RECOGNIZING in particular the right of indigenous families and communities to retain shared responsibility for the upbringing, training, education, and well-being of their children, consistent with the rights of the child,

CONSIDERING that the rights affirmed in treaties, agreements, and other constructive arrangements between States and Indigenous Peoples are, in some situations, matters of international concern, interest, responsibility, and character,

CONSIDERING also that treaties, agreements, and other constructive arrangements, and the relationship they represent, are the basis for a strengthened partnership between Indigenous Peoples and States,

ACKNOWLEDGING that the Charter of the United Nations, the International Covenant on Economic, Social and Cultural Rights and the International Covenant on Civil and Political Rights **(2)**,

as well as the Vienna Declaration and Programme of Action (3), affirm the fundamental importance of the right to self-determination of all peoples, by virtue of which they freely determine their political status and freely pursue their economic, social, and cultural development,

BEARING in mind that nothing in this Declaration may be used to deny any peoples their right to self-determination, exercised in conformity with international law,

CONVINCED that the recognition of the rights of Indigenous Peoples in this Declaration will enhance harmonious and cooperative relations between the State and Indigenous Peoples, based on principles of justice, democracy, respect for human rights, non-discrimination, and good faith,

ENCOURAGING States to comply with and effectively implement all their obligations as they apply to Indigenous Peoples under international instruments, in particular those related to human rights, in consultation and cooperation with the peoples concerned,

EMPHASIZING that the United Nations has an important and continuing role to play in promoting and protecting the rights of Indigenous Peoples,

BELIEVING that this Declaration is a further important step forward for the recognition, promotion, and protection of the rights and freedoms of Indigenous Peoples and in the development of relevant activities of the United Nations system in this field,

RECOGNIZING AND REAFFIRMING that indigenous individuals are entitled without discrimination to all human rights recognized in international law, and that Indigenous Peoples possess collective rights which are indispensable for their existence, well-being, and integral development as peoples,

RECOGNIZING that the situation of Indigenous Peoples varies from region to region and from country to country and that the significance of national and regional particularities and various historical and cultural backgrounds should be taken into consideration,

SOLEMNLY PROCLAIMS the following United Nations Declaration on the Rights of Indigenous Peoples as a standard of achievement to be pursued in a spirit of partnership and mutual respect:

ARTICLE 1

Indigenous Peoples have the right to the full enjoyment, as a collective or as individuals, of all human rights and fundamental freedoms as recognized in the Charter of the United Nations, the Universal Declaration of Human Rights (4), and international human rights law.

ARTICLE 2

Indigenous Peoples and individuals are free and equal to all other peoples and individuals and have the right to be free from any kind of discrimination, in the exercise of their rights, in particular that based on their indigenous origin or identity.

ARTICLE 3

Indigenous Peoples have the right to self-determination. By virtue of that right they freely determine their political status and freely pursue their economic, social, and cultural development.

ARTICLE 4

Indigenous Peoples, in exercising their right to self-determination, have the right to autonomy or self-government in matters relating to their internal and local affairs, as well as ways and means for financing their autonomous functions.

ARTICLE 5

Indigenous Peoples have the right to maintain and strengthen their distinct political, legal, economic, social, and cultural institutions, while retaining their right to participate fully, if they so choose, in the political, economic, social, and cultural life of the State.

ARTICLE 6

Every indigenous individual has the right to a nationality.

ARTICLE 7

1. Indigenous individuals have the rights to life, physical and mental integrity, liberty, and security of person.
2. Indigenous Peoples have the collective right to live in freedom, peace, and security as distinct peoples and shall not be subjected to any act of genocide or any other act of violence, including forcibly removing children of the group to another group.

ARTICLE 8

1. Indigenous Peoples and individuals have the right not to be subjected to forced assimilation or destruction of their culture.
2. States shall provide effective mechanisms for prevention of, and redress for:
 (a) Any action which has the aim or effect of depriving them

of their integrity as distinct peoples, or of their cultural values or ethnic identities;

(b) Any action which has the aim or effect of dispossessing them of their lands, territories, or resources;

(c) Any form of forced population transfer which has the aim or effect of violating or undermining any of their rights;

(d) Any form of forced assimilation or integration;

(e) Any form of propaganda designed to promote or incite racial or ethnic discrimination directed against them.

ARTICLE 9

Indigenous Peoples and individuals have the right to belong to an indigenous community or nation, in accordance with the traditions and customs of the community or nation concerned. No discrimination of any kind may arise from the exercise of such a right.

ARTICLE 10

Indigenous Peoples shall not be forcibly removed from their lands or territories. No relocation shall take place without the free, prior, and informed consent of the Indigenous Peoples concerned and after agreement on just and fair compensation and, where possible, with the option of return.

ARTICLE 11

1. Indigenous Peoples have the right to practice and revitalize their cultural traditions and customs. This includes the right to maintain, protect, and develop the past, present, and future manifestations of their cultures, such as archaeological and historical sites, artifacts, designs, ceremonies, technologies, and visual and performing arts and literature.

2. States shall provide redress through effective mechanisms, which may include restitution, developed in conjunction with Indigenous Peoples, with respect to their cultural, intellectual, religious, and spiritual property taken without their free, prior, and informed consent or in violation of their laws, traditions, and customs.

ARTICLE 12

1. Indigenous Peoples have the right to manifest, practice, develop and teach their spiritual and religious traditions, customs, and ceremonies; the right to maintain, protect, and have access in privacy to their religious and cultural sites; the right to the use and control of their ceremonial objects; and the right to the repatriation of their human remains.

2. States shall seek to enable the access and/or repatriation of ceremonial objects and human remains in their possession through fair, transparent, and effective mechanisms developed in conjunction with Indigenous Peoples concerned.

ARTICLE 13

1. Indigenous Peoples have the right to revitalize, use, develop, and transmit to future generations their histories, languages, oral traditions, philosophies, writing systems, and literatures, and to designate and retain their own names for communities, places, and persons.

2. States shall take effective measures to ensure that this right is protected and also to ensure that Indigenous Peoples can understand and be understood in political, legal, and administrative proceedings, where necessary through the provision of interpretation or by other appropriate means.

ARTICLE 14

1. Indigenous Peoples have the right to establish and control their educational systems and institutions providing education in their own languages, in a manner appropriate to their cultural methods of teaching and learning.

2. Indigenous individuals, particularly children, have the right to all levels and forms of education of the State without discrimination.

3. States shall, in conjunction with Indigenous Peoples, take effective measures, in order for indigenous individuals, particularly children, including those living outside their communities, to have access, when possible, to an education in their own culture and provided in their own language.

ARTICLE 15

1. Indigenous Peoples have the right to the dignity and diversity of their cultures, traditions, histories, and aspirations which shall be appropriately reflected in education and public information.

2. States shall take effective measures, in consultation and cooperation with the Indigenous Peoples concerned, to combat prejudice and eliminate discrimination and to promote tolerance, understanding, and good relations among Indigenous Peoples and all other segments of society.

ARTICLE 16

1. Indigenous Peoples have the right to establish their own media in their own languages and to have access to all forms of non-indigenous media without discrimination.

2. States shall take effective measures to ensure that State-owned media duly reflect indigenous cultural diversity. States, without prejudice to ensuring full freedom of expression, should encourage privately owned media to adequately reflect indigenous cultural diversity.

ARTICLE 17

1. Indigenous individuals and peoples have the right to enjoy fully all rights established under applicable international and domestic labor law.
2. States shall in consultation and cooperation with Indigenous Peoples take specific measures to protect indigenous children from economic exploitation and from performing any work that is likely to be hazardous or to interfere with the child's education, or to be harmful to the child's health or physical, mental, spiritual, moral, or social development, taking into account their special vulnerability and the importance of education for their empowerment.
3. Indigenous individuals have the right not to be subjected to any discriminatory conditions of labor and, inter alia, employment or salary.

ARTICLE 18

Indigenous Peoples have the right to participate in decision-making in matters which would affect their rights, through representatives chosen by themselves in accordance with their own procedures, as well as to maintain and develop their own indigenous decision-making institutions.

ARTICLE 19

States shall consult and cooperate in good faith with the Indigenous Peoples concerned through their own representative institutions in order to obtain their free, prior, and informed consent before adopting and implementing legislative or administrative measures that may affect them.

ARTICLE 20

1. Indigenous Peoples have the right to maintain and develop their political, economic, and social systems or institutions, to be secure in the enjoyment of their own means of subsistence and development, and to engage freely in all their traditional and other economic activities.
2. Indigenous Peoples deprived of their means of subsistence and development are entitled to just and fair redress.

ARTICLE 21

1. Indigenous Peoples have the right, without discrimination, to the improvement of their economic and social conditions, including, inter alia, in the areas of education, employment, vocational training and retraining, housing, sanitation, health, and social security.
2. States shall take effective measures and, where appropriate, special measures to ensure continuing improvement of their economic and social conditions. Particular attention shall be paid to the rights and special needs of indigenous elders, women, youth, children, and persons with disabilities.

ARTICLE 22

1. Particular attention shall be paid to the rights and special needs of indigenous elders, women, youth, children, and persons with disabilities in the implementation of this Declaration.
2. States shall take measures, in conjunction with Indigenous Peoples, to ensure that indigenous women and children enjoy the full protection and guarantees against all forms of violence and discrimination.

ARTICLE 23

Indigenous Peoples have the right to determine and develop priorities and strategies for exercising their right to development. In particular, Indigenous Peoples have the right to be actively involved in developing and determining health, housing, and other economic and social programs affecting them and, as far as possible, to administer such programs through their own institutions.

ARTICLE 24

1. Indigenous Peoples have the right to their traditional medicines and to maintain their health practices, including the conservation of their vital medicinal plants, animals, and minerals. Indigenous individuals also have the right to access, without any discrimination, to all social and health services.
2. Indigenous individuals have an equal right to the enjoyment of the highest attainable standard of physical and mental health. States shall take the necessary steps with a view to achieving progressively the full realization of this right.

ARTICLE 25

Indigenous Peoples have the right to maintain and strengthen their distinctive spiritual relationship with their traditionally owned or otherwise occupied and used lands, territories, waters and coastal seas, and other resources and to uphold their responsibilities to future generations in this regard.

ARTICLE 26

1. Indigenous Peoples have the right to the lands, territories, and resources which they have traditionally owned, occupied, or otherwise used or acquired.
2. Indigenous Peoples have the right to own, use, develop and control the lands, territories and resources that they possess by reason of traditional ownership or other traditional occupation or use, as well as those which they have otherwise acquired.
3. States shall give legal recognition and protection to these lands, territories, and resources. Such recognition shall be conducted with due respect to the customs, traditions, and land tenure systems of the Indigenous Peoples concerned.

ARTICLE 27

States shall establish and implement, in conjunction with Indigenous Peoples concerned, a fair, independent, impartial, open, and transparent process, giving due recognition to Indigenous Peoples' laws, traditions, customs, and land tenure systems, to recognize and adjudicate the rights of Indigenous Peoples pertaining to their lands, territories, and resources, including those which were traditionally owned or otherwise occupied or used. Indigenous Peoples shall have the right to participate in this process.

ARTICLE 28

1. Indigenous Peoples have the right to redress, by means that can include restitution or, when this is not possible, just, fair, and equitable compensation, for the lands, territories, and resources which they have traditionally owned or otherwise occupied or used, and which have been confiscated, taken, occupied, used, or damaged without their free, prior, and informed consent.
2. Unless otherwise freely agreed upon by the peoples concerned, compensation shall take the form of lands, territories, and resources equal in quality, size, and legal status or of monetary compensation or other appropriate redress.

ARTICLE 29

1. Indigenous Peoples have the right to the conservation and protection of the environment and the productive capacity of their lands or territories and resources. States shall establish and implement assistance programs for Indigenous Peoples for such conservation and protection, without discrimination.
2. States shall take effective measures to ensure that no storage or disposal of hazardous materials shall take place in the lands or territories of Indigenous Peoples without their free, prior, and informed consent.
3. States shall also take effective measures to ensure, as needed, that programs for monitoring, maintaining, and restoring the health of Indigenous Peoples, as developed and implemented by the peoples affected by such materials, are duly implemented.

ARTICLE 30

1. Military activities shall not take place in the lands or territories of Indigenous Peoples, unless justified by a relevant public interest or otherwise freely agreed with or requested by the Indigenous Peoples concerned.
2. States shall undertake effective consultations with the Indigenous Peoples concerned, through appropriate procedures and in particular through their representative institutions, prior to using their lands or territories for military activities.

ARTICLE 31

1. Indigenous Peoples have the right to maintain, control, protect, and develop their cultural heritage, traditional knowledge, and traditional cultural expressions, as well as the manifestations of their sciences, technologies, and cultures, including human and genetic resources, seeds, medicines, knowledge of the properties of fauna and flora, oral traditions, literatures, designs, sports and traditional games, and visual and performing arts. They also have the right to maintain, control, protect, and develop their intellectual property over such cultural heritage, traditional knowledge, and traditional cultural expressions.
2. In conjunction with Indigenous Peoples, States shall take effective measures to recognize and protect the exercise of these rights.

ARTICLE 32

1. Indigenous Peoples have the right to determine and develop priorities and strategies for the development or use of their lands or territories and other resources.
2. States shall consult and cooperate in good faith with the Indigenous Peoples concerned through their own representative institutions in order to obtain their free and informed consent prior to the approval of any project affecting their lands or territories and other resources, particularly in connection with the development, utilization or exploitation of mineral, water, or other resources.
3. States shall provide effective mechanisms for just and fair redress for any such activities, and appropriate measures shall be taken to mitigate adverse environmental, economic, social, cultural, or spiritual impact.

ARTICLE 33

1. Indigenous Peoples have the right to determine their own identity or membership in accordance with their customs and traditions. This does not impair the right of indigenous individuals to obtain citizenship of the States in which they live.
2. Indigenous Peoples have the right to determine the structures and to select the membership of their institutions in accordance with their own procedures.

ARTICLE 34

Indigenous Peoples have the right to promote, develop, and maintain their institutional structures and their distinctive customs, spirituality, traditions, procedures, practices, and, in the cases where they exist, juridical systems or customs, in accordance with international human rights standards.

ARTICLE 35

Indigenous Peoples have the right to determine the responsibilities of individuals to their communities.

ARTICLE 36

1. Indigenous Peoples, in particular those divided by international borders, have the right to maintain and develop contacts, relations, and cooperation, including activities for spiritual, cultural, political, economic, and social purposes, with their own members as well as other peoples across borders.
2. States, in consultation and cooperation with Indigenous Peoples, shall take effective measures to facilitate the exercise and ensure the implementation of this right.

ARTICLE 37

1. Indigenous Peoples have the right to the recognition, observance, and enforcement of treaties, agreements, and other constructive arrangements concluded with States or their successors and to have States honour and respect such treaties, agreements, and other constructive arrangements.
2. Nothing in this Declaration may be interpreted as diminishing or eliminating the rights of Indigenous Peoples contained in treaties, agreements, and other constructive arrangements.

ARTICLE 38

States in consultation and cooperation with Indigenous Peoples, shall take the appropriate measures, including legislative measures, to achieve the ends of this Declaration.

ARTICLE 39

Indigenous Peoples have the right to have access to financial and technical assistance from States and through international cooperation, for the enjoyment of the rights contained in this Declaration.

ARTICLE 40

Indigenous Peoples have the right to access to and prompt decision through just and fair procedures for the resolution of conflicts and disputes with States or other parties, as well as to effective remedies for all infringements of their individual and collective rights. Such a decision shall give due consideration to the customs, traditions, rules, and legal systems of the Indigenous Peoples concerned and international human rights.

ARTICLE 41

The organs and specialized agencies of the United Nations system and other intergovernmental organizations shall contribute to the full realization of the provisions of this Declaration through the mobilization, inter alia, of financial cooperation and technical assistance. Ways and means of ensuring participation of Indigenous Peoples on issues affecting them shall be established.

ARTICLE 42

The United Nations, its bodies, including the Permanent Forum on Indigenous Issues, and specialized agencies, including at the country level, and States shall promote respect for and full application of the provisions of this Declaration and follow up the effectiveness of this Declaration.

ARTICLE 43

The rights recognized herein constitute the minimum standards for the survival, dignity, and well-being of the Indigenous Peoples of the world.

ARTICLE 44

All the rights and freedoms recognized herein are equally guaranteed to male and female indigenous individuals.

ARTICLE 45

Nothing in this Declaration may be construed as diminishing or extinguishing the rights Indigenous Peoples have now or may acquire in the future.

ARTICLE 46

1. Nothing in this Declaration may be interpreted as implying for any State, people, group, or person any right to engage in any activity or to perform any act contrary to the Charter of the United Nations or construed as authorizing or encouraging any action which would dismember or impair, totally or in part, the territorial integrity or political unity of sovereign and independent States.
2. In the exercise of the rights enunciated in the present Declaration, human rights and fundamental freedoms of all shall be respected. The exercise of the rights set forth in this Declaration shall be subject only to such limitations as are determined by law and in accordance with international human rights obligations. Any such limitations shall be non-discriminatory and strictly necessary solely for the purpose of securing due recognition and respect for the rights and freedoms of others and for meeting the just and most compelling requirements of a democratic society.
3. The provisions set forth in this Declaration shall be interpreted in accordance with the principles of justice, democracy, respect for human rights, equality, non-discrimination, good governance, and good faith.

(2) See resolution 2200 A (XXI), annex.
(3) A/CONF.157/24 (Part I), chap. III.
(4) Resolution 217 A (III).

DIGNITY

In Honor of the Rights of Indigenous Peoples

DUST JACKET: *Woman with Pipe, Haiti, 1983;*
Quechua Boy, Peru, 2006
TITLE PAGE: *Masai Warrior Initiate, Kenya, 1985*
PAGES 6–7: *Samburu Women, Kenya, 1985*

Compilation © 2010 powerHouse Cultural
 Entertainment, Inc.
Photography & text © 2010 Dana Gluckstein
Foreword © 2010 Desmond Tutu
Introduction © 2010 Oren R. Lyons
Epilogue © 2010 Larry Cox

Acknowledgements epigraph from *Honey from the Rock: An*
Introduction to Jewish Mysticism © 2000 by Rabbi Lawrence
Kushner. Permission granted by Jewish Lights Publishing,
Woodstock, VT.

All rights reserved. No part of this book may
be reproduced in any manner in any media, or
transmitted by any means whatsoever, electronic
or mechanical (including photocopy, film or video
recording, Internet posting, or any other informa-
tion storage and retrieval system), without the
prior written permission of the publisher.

Published in the United States by
powerHouse Books,
a division of powerHouse Cultural
Entertainment, Inc.
37 Main Street, Brooklyn, NY 11201-1021
telephone: 212.604.9074, fax: 212.366.5247
email: dignity@powerhousebooks.com

website: www.powerhousebooks.com
First edition, 2010

Library of Congress Control Number: 2010929923

Hardcover ISBN 978-1-57687-562-9

Printing and binding by
Midas Printing, Inc., China

Book design by Opto Design

A complete catalog of powerHouse Books and
Limited Editions is available upon request; please
call, write, or visit our website.

10 9 8 7 6 5 4 3 2 1

Printed and bound in China